Postcard History Series

Redlands

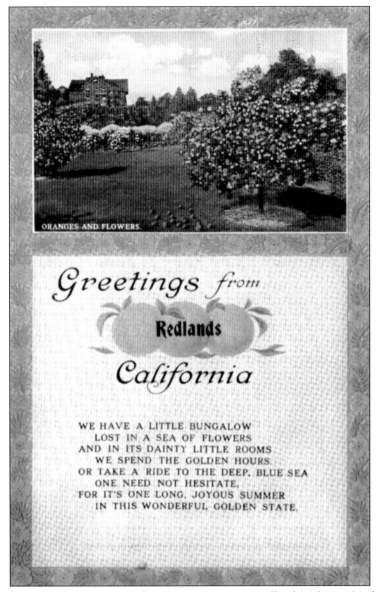

How could anyone resist this scenic and poetic invitation to Redlands? The card is from c. 1910.

ON THE FRONT COVER: Bike racing is nothing new to Redlands. This postcard features a 1909 photograph of six entrants in the motorcycle division of the Hill Climb posing in front of the Casa Loma Hotel. From left to right, Al Gonzales, George Danielson, and Herbert Gowland rode Excelsior motorcycles. Chauncey Crum and Severn West rode Harley Davidsons, and at the right, winner Charles Gordon rode an Excelsior.

ON THE BACK COVER: The A. K. Smiley Library and surrounding park were the gift of Albert K. Smiley. The library was built at a cost of more than $60,000, which was quite a lot of money in 1898, much of which Smiley had to borrow. The library is well known for its collections, archives, and Heritage Room, all valuable resources for reading and research.

POSTCARD HISTORY SERIES

Redlands

Fred Edwards and Randy Briggs

Copyright © 2006 by Fred Edwards and Randy Briggs
ISBN 0-7385-4680-1

Published by Arcadia Publishing
Charleston SC, Chicago IL, Portsmouth NH, San Francisco CA

Printed in the United States of America

Library of Congress Catalog Card Number: 2006928747

For all general information contact Arcadia Publishing at:
Telephone 843-853-2070
Fax 843-853-0044
E-mail sales@arcadiapublishing.com
For customer service and orders:
Toll-Free 1-888-313-2665

Visit us on the Internet at www.arcadiapublishing.com

*A thank offering to all who have made and continue
to make Redlands a good place in which to live.*

Variant wording based on the dedication tablet on the Redlands Bowl Prosellis

Acknowledgments

The authors would like to thank the following publishers for producing not simply postcards but for providing a photographic history to be cherished for generations to come: M. Rieder Publishing, C. T. Photocrom Company, Pilsbury Picture Company, Newman Post Card Company, Detroit Publishing Company, Western Publishing and Novelty Company, Souvenir Publishing Company, Benham Company, Pacific Novelty Company, B. R. Montgomery, Haines Photo Company, J. T. Bowers Photo Company, Edward H. Mitchell, Locantore, Columbia Wholesale Supply, Colourpicture, American Image Photographers, Upston Studio, Arthur Commercial Press, Redlands News Company, J. H. Dinwoodie, Paul C. Koeber Company, Tucker Book and Stationery Company, Renfro-Haven Company, Rice and Sons, M. Kashower Company, Artvue Post Card Company, Curt Teich and Company, and The Albertype Company.

Contents

Preface		6
Introduction		7
1.	Redlands: Our Town	9
2.	A Thriving Business Center	19
3.	Hotels and Inns: Come to Visit, and Stay	43
4.	The Smileys: A Heritage of Vision and Generosity	53
5.	A Place of Beauty and Enjoyment	61
6.	A City of Churches	73
7.	Education: The Key to the Future	83
8.	Stately Homes and Neighborhoods	95
9.	Panoramas and Vistas	115
10.	A Mid-Century View	121
Bibliography		127

Preface

Randy Briggs and Fred Edwards sing side by side in the baritone section of the Redlands Community Chorus. During a break in rehearsal, Fred asked the question: "Randy, why don't we use your vintage postcards to write a book about Redlands?" After a brief pause, Randy said, "Okay, when do we start?" Neither one was inclined to delay to later what could be done sooner, so the project was initiated. Some of the picture postcards had already been exhibited in the Redlands Post Office Museum, which was established by Edwards several years ago. So the authors already had the basis of some choice selections. Both Randy and Fred have an avid interest in the history of Redlands, "their town," and enjoy and participate in its many cultural offerings.

Randy Briggs is co-owner of the Fred Coops Galleries shop in Redlands, which is a center for numismatists, philatelists, and other collectors. He surely got into that business because he likes to collect rare and interesting "stuff." His personal Redlands-related collection includes an impressive array of books, papers, documents, and other ephemera. His catalogue of more than 900 vintage picture postcards of Redlands is surely the most complete to be found anywhere. In addition to his collecting, he claims to always sing in tune and is a connoisseur of fine wines.

Fred Edwards, a retired United Methodist pastor and 26-year staff writer for a Roman Catholic homily service, continues to write on various topics for publication and for his own enjoyment. An artist as well as a writer, he works with his wife in creating fine art etchings, many of which depict the Redlands area.

Briggs and Edwards intend this book of vintage postcard views as a companion to Arcadia Publishing's Images of America: *Redlands* by Larry E. Burgess and Nathan D. Gonzales.

—Fred Edwards and Randy Briggs
May 2006

Introduction

Why postcards? It is utterly astounding that the small town of Redlands produced some 900 designs of picture postcards from the mid-1880s to the 1960s. Almost all of them were from photographic images. The town, after all, was very small. The population was less than 15,000 until the mid-1950s, and yet few cities of much greater size—New York and Chicago, for example—produced more picture postcards in the late 1800s and early 1900s than little Redlands. A postcard collector recently told Randy Briggs that he knew of only two other places in the United States that had produced such an array of cards, and those were New York's Lake Mohonk resort and our nearby sister city of Riverside, with its famous Mission Inn.

The burgeoning and still relatively new art of photography spurred an early interest in picture postcards. Photographers found that pictures that could be purchased and mailed would be a profitable adjunct to their business. The post office even offered a special rate for mailing postcards. Some photo cards were even hand tinted by the photographers for special appeal. Printers very soon got into the business and began printing some cards in color. Businesses discovered that picture postcards were a handy way to advertise a market or a clothing store. Some merely depicted building facades, while others showed store interiors with staff standing ready to serve customers.

Redlands offered an impressive number of local attractions. The Wyatt Theater boasted the fourth largest stage in California, seating 1,300 people, and drew world famous artists, musical troupes, and even opera. The Smiley estate was a horticultural marvel, and its gates were open to visitors. Orange orchards were a wondrous sight, especially to eastern visitors, and some were outlined with palm trees and even roses. There were stately homes, many in the Victorian or Queen Anne style, some 300 of which are still in existence today. There was a fine library and surrounding park, substantial downtown buildings, and some picturesque hotels, most notably the Casa Loma Hotel. All these were depicted from every angle, and by the dozens and even hundreds, for mailing to distant places. Special occasions, such as presidential visits, also made interesting material.

Postcards of local attractions became a popular way to mail a friend a scene of where one was visiting. Thousands of tourists were coming to Redlands each year, and they were happy to mail pictures of the town to their friends. Thus the Redlands Chamber of Commerce, real estate brokers, and tourist-friendly businesses were getting plenty of free advertising, because people were paying for the picture cards and then paying the postage.

The pictures often evoke the styles of clothing, the mode of transportation, and the ambiance of both time and place. Young people are seen happily enjoying a picnic. One sees now antique-

looking automobiles, motorcycles, and railcars. Women in long, heavy dresses and hats and men in suits and hats seem posed on street corners. Finely clothed people appear riding in horse-drawn carriages. Yet it seems very strange to us now that those early photographers so often chose to show scenes and buildings without any people at all.

The messages on the vintage cards are often as interesting and entertaining as the pictures. One on a design of oranges says, "This is the way they pack oranges here in California." Another opines, "The weather here is simply marvelous," and still another invites the addressee, "I wish you could come out here and see this beautiful little town." There are love notes and "wish you were here" sentiments. The quality of the hostelry of the time is acclaimed. "I am staying in a lovely room in the Windsor Hotel, and the food is excellent." Another declares, "The quality of the accommodations is unequaled anywhere I've been, and the service is superior." But there were also some complaints, mostly concerning the heat, flies, or wind.

Almost from its founding and until the 1960s, the University of Redlands had a selection of postcards in the university bookstore showing scenes of the campus, which students could purchase to write to family or friends. We need to remind ourselves that that was a time when there were no telephones in dormitory rooms and, in earlier times, not even in a dorm hallway. Cell phones would have been the stuff of imaginative comic strips, such as Dick Tracy, in which his wrist radio played such a part. Such undreamed-of things as computers and e-mail were many decades in the future.

Picture postcards in resort locales, such as Hawaii, portray sunsets, colorful fish or birds, hula dancers, or people basking in the sun. In some countries you can find cards of cathedrals and other famous buildings. Many art museums offer cards depicting the work of famous artists. But where are the picture postcards of our town today? They've disappeared. We have looked in stores and not found a single one. Apparently we find it much easier to take a shot on a picture phone and e-mail it, or with a camera to put it in an album or on a disc. Perhaps we have lost something of the more personal touch of a time when people actually wrote a note and mailed it, sometimes even sealed with a kiss. And perhaps any town—our town—has to find ever new ways consonant with new times to tell its story.

These postcards tell the story of Redlands in the way its people saw it in an earlier time, and the way they wanted other people to see it. The cards are a rich archive of the town's history. We have enjoyed looking into past years of Redlands, and think you will also. Enjoy!

<div style="text-align: right;">
—Fred Edwards and Randy Briggs

May 20, 2006
</div>

One

Redlands
Our Town

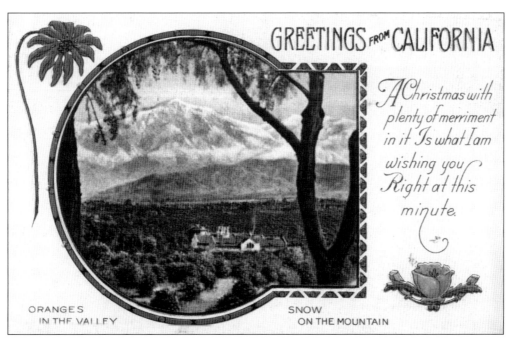

This early 1900s Christmas card shows the contrasts of a Redlands winter scene, with snow on the mountains and oranges growing in the valley.

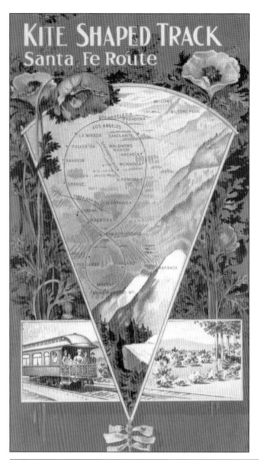

These two cards describe Santa Fe's innovative 158-mile Kite Shaped Track, especially created for viewing pleasure and routed through scenic areas of four counties and towns such as Redlands, Riverside, Corona, Anaheim, Los Angeles, Pasadena, Monrovia, Claremont, and San Bernardino. Initiated in 1892, a round-trip fare cost $3.65.

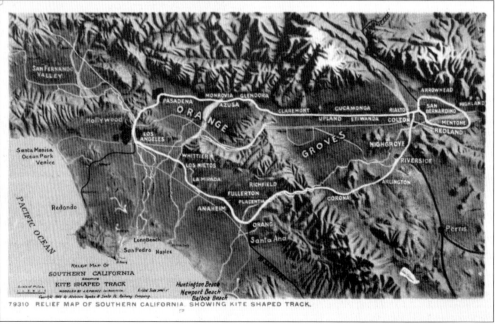

This cartoon-style postcard was not unique to Redlands. Cards were sold in various towns, and the town name was printed in to order on the banner. It was a good way of advertising the town to people in other places. Thousands were sold in towns across the country.

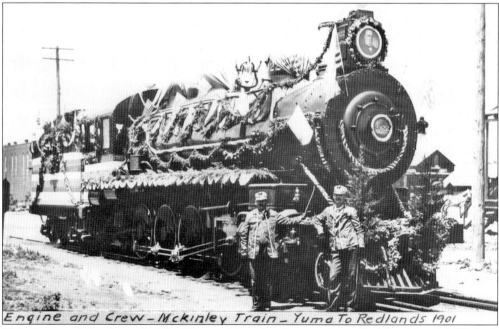

This decorated Southern Pacific 135-ton Mastodon locomotive pulled President McKinley's train from Yuma to Redlands in 1901. Note the president's picture in the headlight housing. His visit had a remarkable impact on the town. A bust of McKinley stands in Smiley Park near the library.

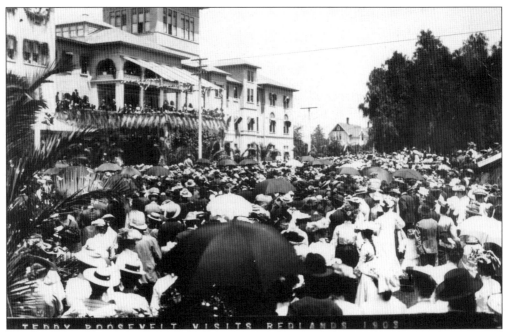

Pres. Theodore Roosevelt arrived in Redlands by train on May 7, 1903, and addressed a huge crowd from atop the carriage porch of the Casa Loma Hotel. He also went to visit his friend Albert Smiley at his home in Cañon Crest Park.

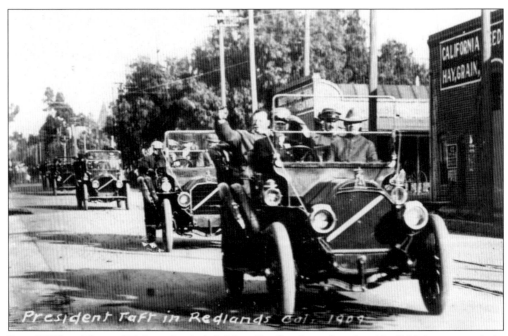

Pres. William Howard Taft made a brief visit to Redlands on October 12, 1909, but was only in town for an hour. He arrived at the Santa Fe station in San Bernardino and came to Redlands in an auto motorcade. Taft made a brief address on Orange Street near the Casa Loma Hotel. His audience was a crowd of children, and the speech was concerning the meaning of the flag.

REDLANDS, CALIFORNIA

A Gem set in a circlet of Sunkist Sierras.
Fine schools, High School, Manual Arts and University;
Splendid churches—to meet every need;
Homes, the prettiest, happiest, healthiest;
The original Flyless Town.
Paved streets and fine roads-the auto paradise;

Peerless Prohibition City: which means:
Supervised parks and playgrounds full of rollicking children,
Municipal water system and ornamental street lights,
See Smiley Heights and want to live forever:
Buy a home and realize your wishes.

Compliments of REDLANDS Y. P. S. C. E.

The message already written, with a picture of the valley and a small picture on the obverse side, the sender has only to address the card and apply a 1¢ stamp. The sponsor of this *c.* 1915 card is the Youth Prohibition Society of Christian Endeavor (YPSCE).

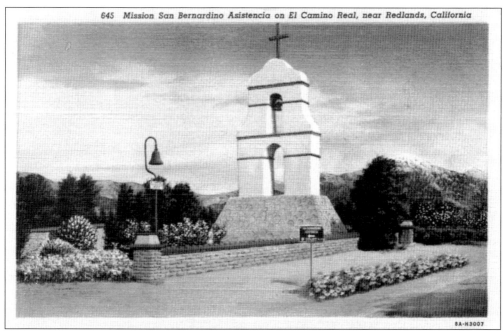

The Asistencia is a tie to California's Spanish heritage. More properly called an "estancia" (outpost), it was built in 1819 on the Rancho San Bernardino and was owned by the Mission San Gabriel. This monument was built in 1938–1939, and a nearby reconstructed adobe commemorates the estancia.

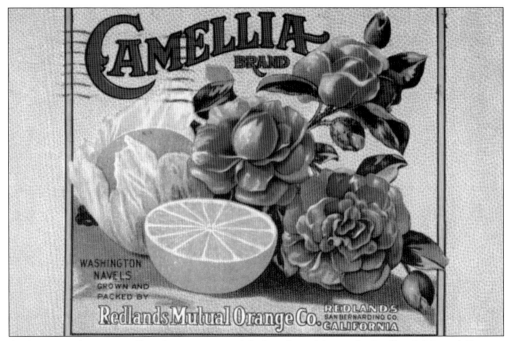

Artists created an array of lovely orange crate labels such as this one for Redlands Mutual Orange Company. The earliest and best designs were produced by stone lithography, such as this 1910 example. Later designs used a four-color printing press process. The brand, "Camellia" in this case, designated a special size and quality of fruit. These crate label designs have become highly collectable in recent years.

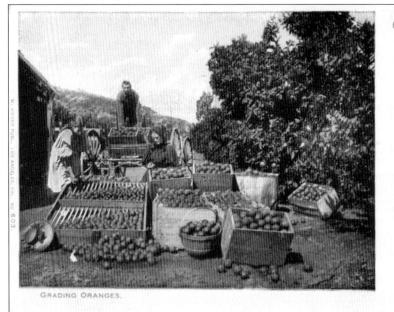

In the very early days of the citrus industry, fruit was sometimes graded and boxed in the orchards, though this was very inefficient and did not properly prepare the fruit for shipping. Packinghouses washed, waxed, graded, and sized, and then hand packed the fruit in crates for shipping.

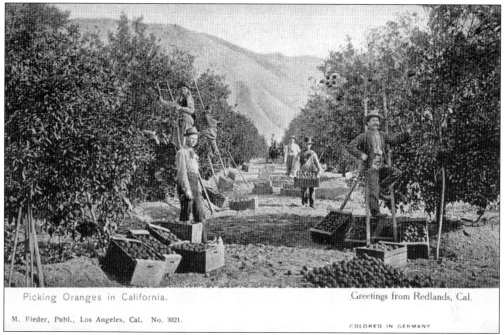

Picking Oranges in California. Greetings from Redlands, Cal.
M. Rieder, Publ., Los Angeles, Cal. No. 3021.
COLORED IN GERMANY

The photographer set up this shot showing pickers and their ladders. In the distance, a horse-drawn wagon comes to haul away the filled boxes. The trees look rather thin and straggly compared to modern standards of what a healthy and producing orange tree should be.

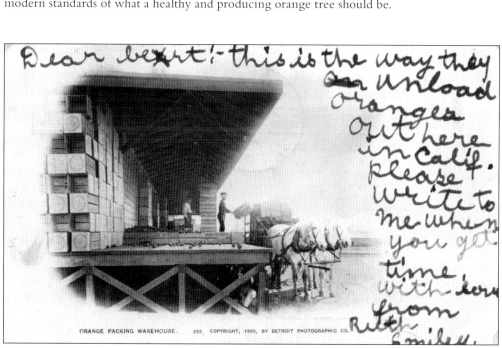

ORANGE PACKING WAREHOUSE. 299 COPYRIGHT, 1900, BY DETROIT PHOTOGRAPHIC CO.

This 1903 postcard shows a horse cart delivering boxes of oranges to a packinghouse. Even more interesting is the message from Ruth Smiley to Albert K. Smiley Jr., who was then studying at Haverford College in Pennsylvania. The message is all on the picture side and can be read easily.

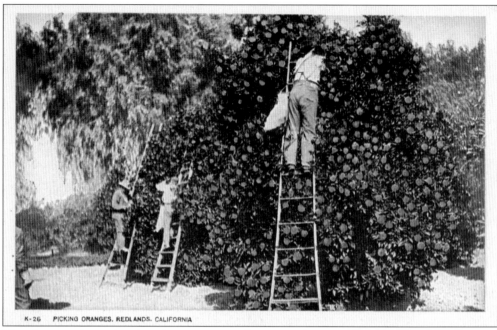

The photographer colored in the oranges on these trees for the printing process and probably added a few. He also made them rather large, more like very big grapefruit. Probably the grower would have wished to have such a crop.

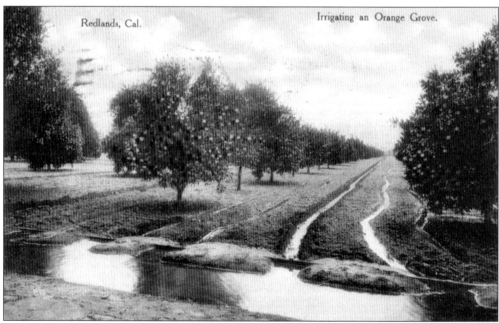

In the early decades of the citrus industry, groves were irrigated in furrows supplied by ditches or large pipelines. In more recent years, irrigation has been done by more efficient and environmentally sensitive ways, but this is what was typical when this 1910 picture postcard was taken.

San Bernardino County's version of a county fair began in 1911 and was called the National Orange Show, because so much of the area's agriculture was devoted to raising oranges. The 1913 postcard at right shows the Redlands exhibit, with an arrowhead design created by tissue-wrapped fruit. The second card, a year or two later, shows intricate designs made with fancy-pack, tissue-wrapped fruit. Fancy-packed boxes were select quality oranges, which were individually hand wrapped in very thin papers, as shown on the "Camellia" box label on page 14. The wraps, sometimes in colors, were for show only and often done for special orders. The entire content of a box might be wrapped or just some of the fruit, which could be arranged in the box to form a design.

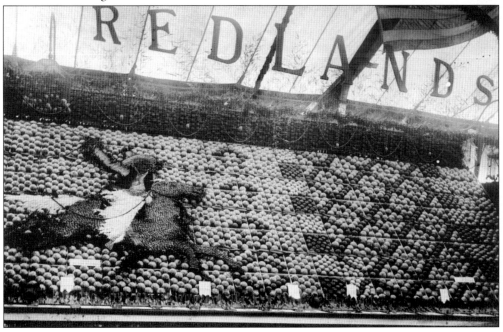

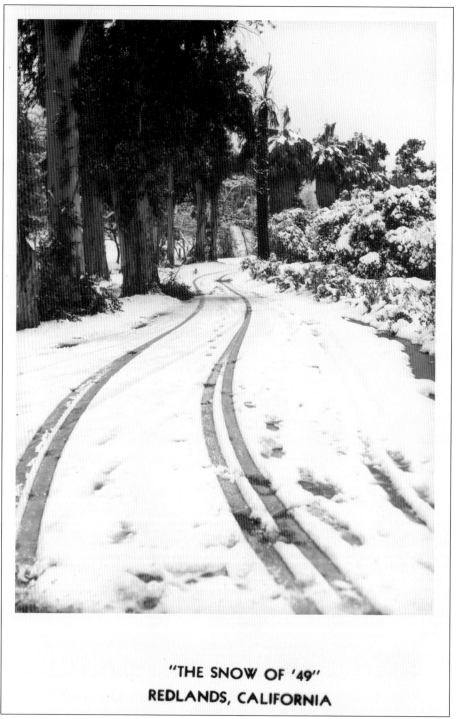

"THE SNOW OF '49"
REDLANDS, CALIFORNIA

Yes, it does snow in Redlands, perhaps once in a decade or so. The snow of 1949 was enough to make a photographer want to catch the scene. About three years later, a heavier and wet snow blanketed Redlands, enough to break tree limbs. Students at the University of Redlands made snowmen on the "Quad" that lasted several days.

Two

A Thriving Business Center

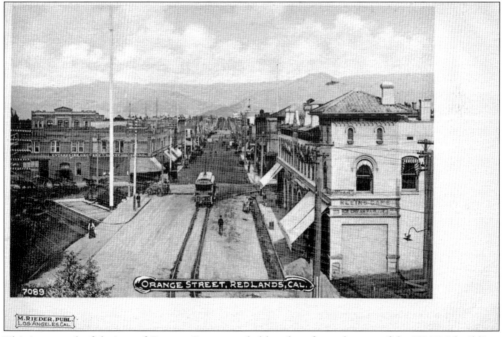

This is a wonderful view of Orange Street, probably taken from the top of the YMCA building at Vine and Cajon Streets. It shows the Fisher Building on the right and the Triangle with its flagpole on the left. The Enterprise Grocery is just beyond. Taken about 1905, this picture shows the streetcar bound for Smiley Heights.

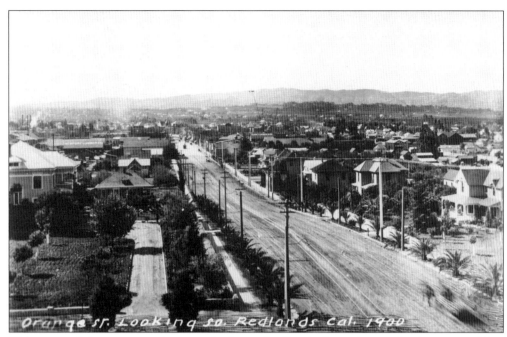

This turn-of-the-century photograph shows Redlands from the north. An enterprising photographer snapped this shot from the balcony of the Casa Loma Hotel on Colton Avenue. Careful examination of the picture reveals several lumber companies as well as the overall downtown district. The low-lying ridge to the right is Cañon Crest Park.

The dark and massive building at the center of the picture is the YMCA, built in 1895 and located at the corner of Cajon and Vine Streets. The Fisher block is on the left.

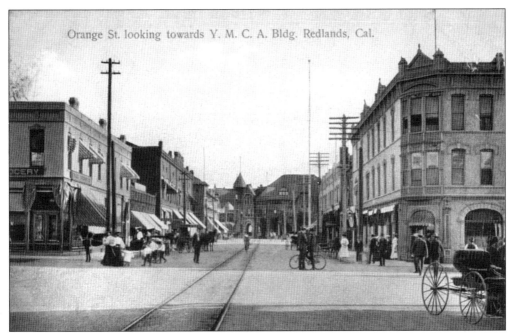

Probably taken in the early 1900s, this view of the heart of the city shows Orange Street as it crosses State Street. No cars yet, but bicycles, horses, and buggies abound to transport the shoppers and business people. The First National Bank of Redlands is on the right, and the Star Grocery is on the left.

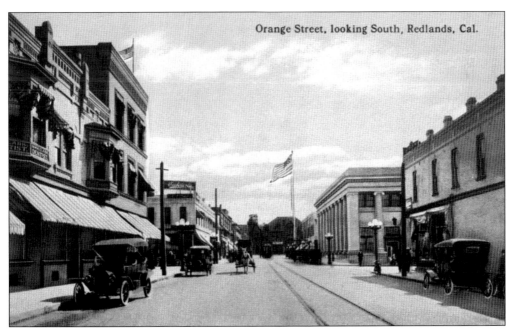

In this similar view of Orange Street, the First National Bank on the right has had a major remodel, adding columns to its facade to portray that depositors' money is safe here.

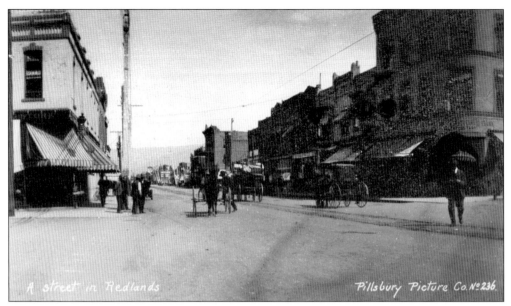

The Redlands National Bank is visible in the shadows on the right. During the early 1900s, it issued its own currency. The paper money was standard government issue but bore the name of the local bank. In the extreme distance is the tower of the Casa Loma Hotel.

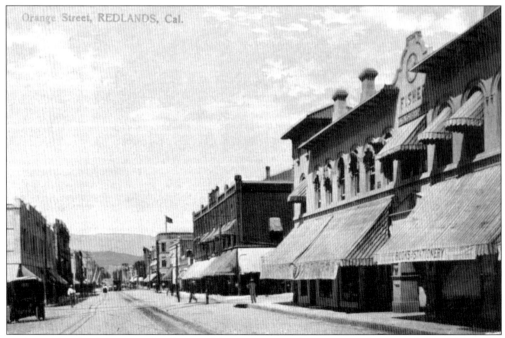

Henry Fisher built his grand Fisher Building in 1899 to house not only shops for retail but also the offices of the Redlands Street Railroad Company, of which he was president. The streetcars stopped right outside his office.

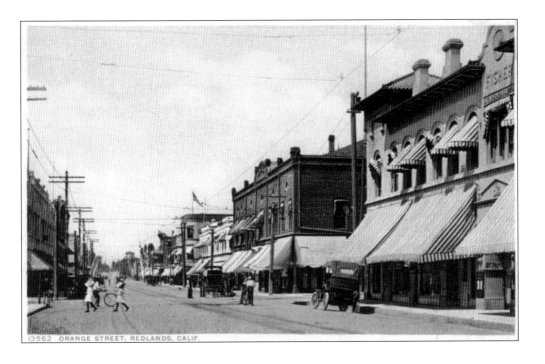

This first photograph of Orange Street, taken in the early 1900s, shows dirt streets and few automobiles. The second photograph, taken a few years later, shows a modernized downtown with paved streets and automobiles on both sides.

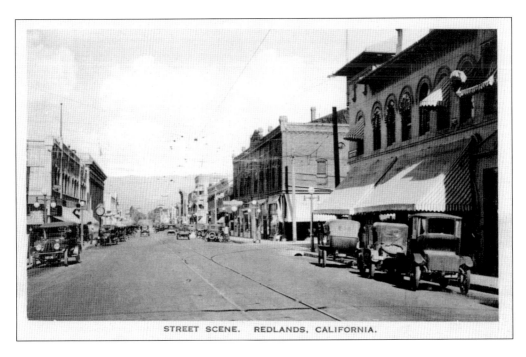

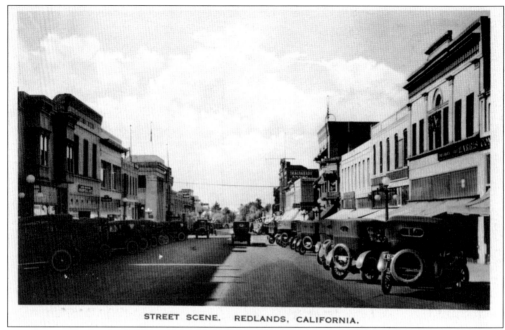

Looking west on State Street, this view shows the intersection of Orange Street with its banks, and in the foreground is the Harris Company, which had locations in Redlands and San Bernardino. The Harris Company served the Inland Empire with quality merchandise and clothing and is one of the few businesses to survive into the 21st century.

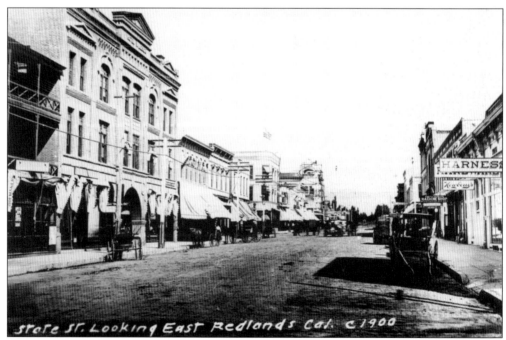

Looking east on State Street, Redlands in 1900 still has the feel of an old Western town. The tall building down the street at left is the Elks Building, apparently under construction, placing the time of this card in 1902 or 1903. The veranda of the Windsor Hotel is on the extreme left.

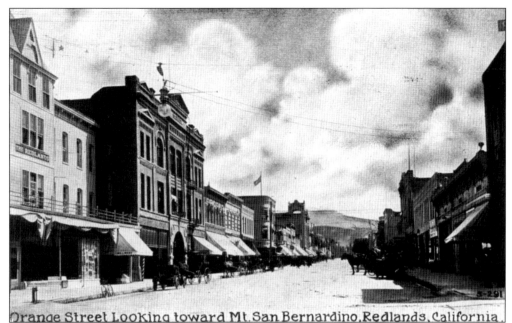

Incorrectly titled "Orange Street," this view of State Street shows the remodeled Windsor Hotel at the far left. Much of the veranda has been removed, and the sign now says "The Redlands."

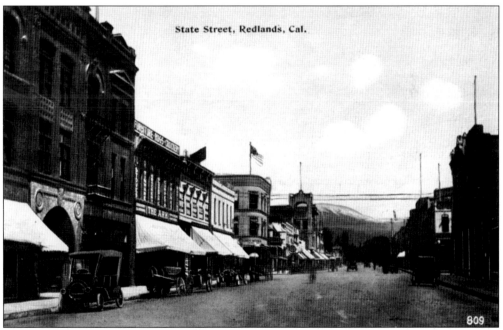

The general store known as "The Ark" is featured on this card. It is the second building on the left. The storefront advertised all kinds of products, from furniture and rugs, to stoves, trunks, and crockery.

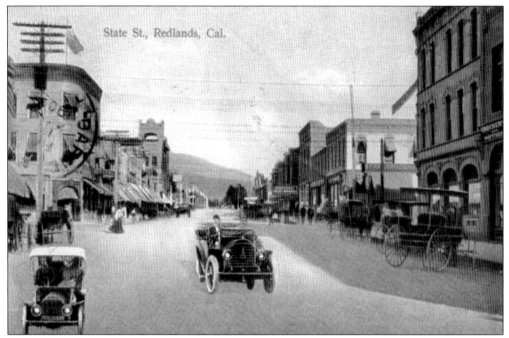

This postcard from 1909 shows the Star Grocery on the far right (southeast) corner. Although the photograph was taken near the turn of the century, the picture has been modernized by the insertion of two automobiles, both of which are totally out of proportion with the horses and buggies.

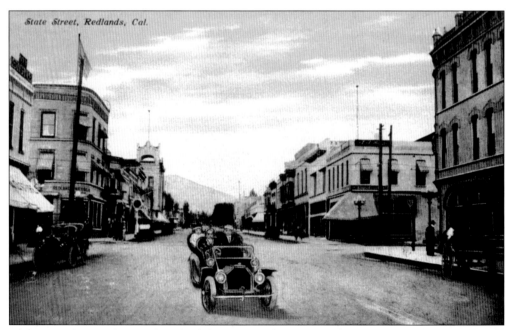

This is another modernized card of the corner of Orange and State Streets showing the old First National Bank of Redlands building. An automobile was added that was not in the original photograph.

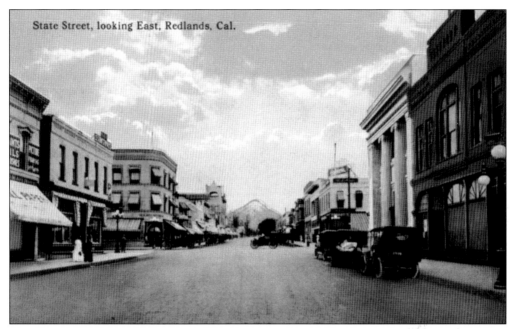

This view to the east on State Street shows the newly rebuilt First National Bank, with its massive columns on the right. Curiously, a mountain has been placed at the end of the street.

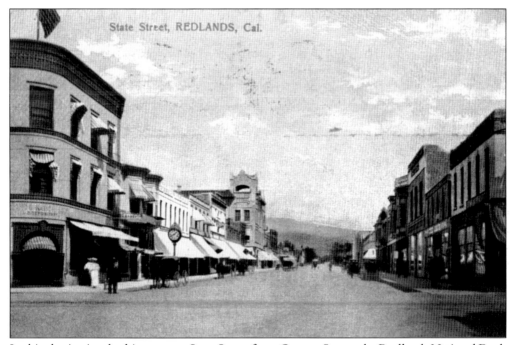

In this classic view looking east on State Street from Orange Street, the Redlands National Bank is on the left corner. The Elks Lodge, with its tall tower, looms in the distance.

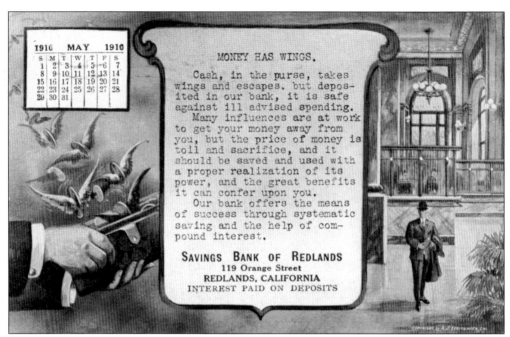

An advertising card from the Savings Bank of Redlands declares that "Money Has Wings," and if one wishes to keep his money, he should invest with them.

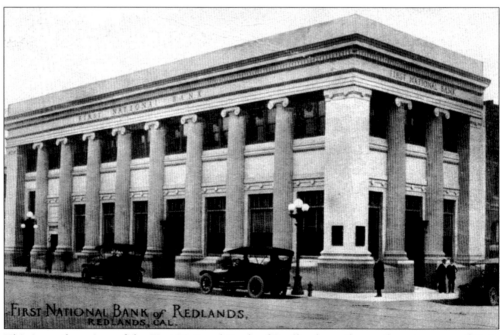

This is another view of the First National Bank of Redlands on the southwest corner of State and Orange Streets.

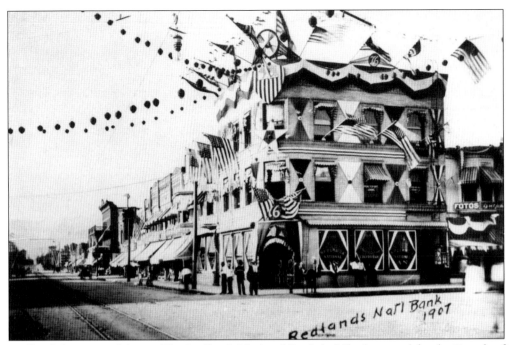

Redlands loves to celebrate. The Redlands National Bank is fully decorated for the Fourth of July, complete with banners and flags honoring 1776.

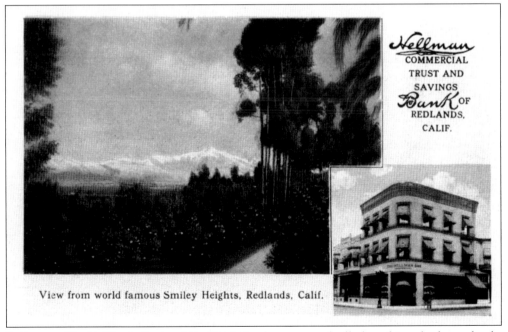

Following World War I, the local Redlands banks were gradually bought up by larger banks from the Los Angeles area. The Redlands National Bank was taken over by the Hellman Bank in the 1920s.

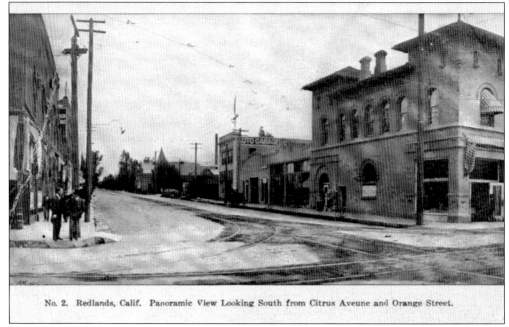

No. 2. Redlands, Calif. Panoramic View Looking South from Citrus Aveune and Orange Street.

This postcard features a view looking east from the Fisher Block on Citrus Avenue. The tall smokestack, just past the auto garage, belongs to the Redlands Power and Light Company on Sixth Street.

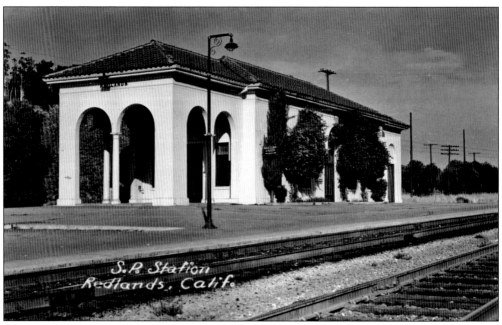

This Southern Pacific Railroad station was located just west of downtown. The original station was on Orange Street, just north of Water Street and across from the Finney Building.

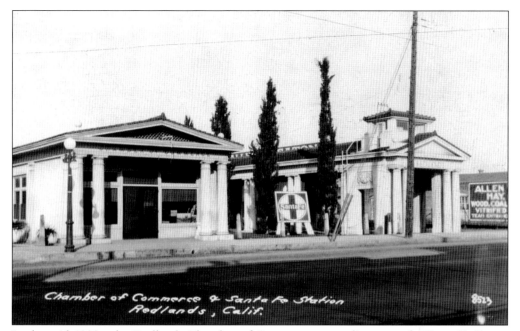

In the mid-1930s, the Redlands Chamber of Commerce was adjacent to the Santa Fe Depot on Orange Street.

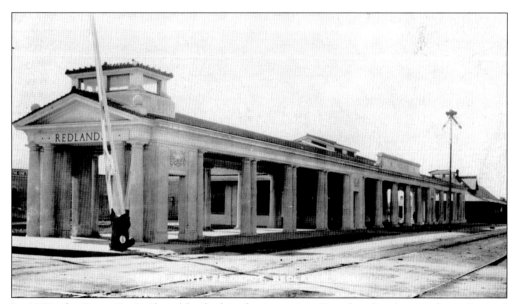

In 1909, the Santa Fe Railroad built this classic station. For decades, it served tourists and businesses alike, bringing countless thousands to Redlands.

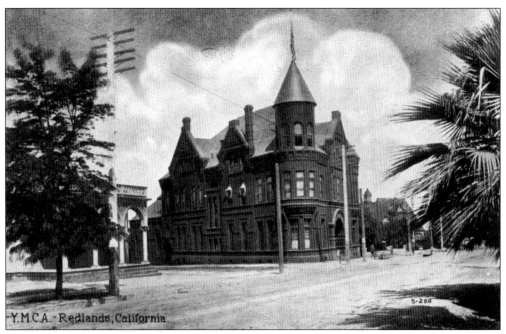

The YMCA building, located at the northwest corner of Cajon and Vine Streets, was completed in 1895. Later it was used as the city hall until it was destroyed by fire in 1939.

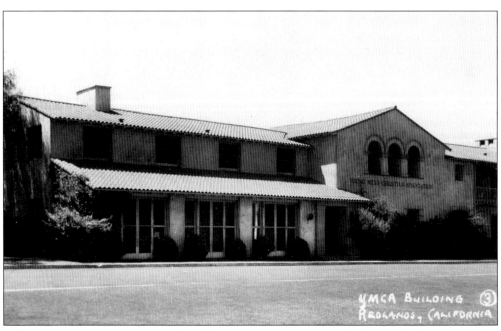

Following the move from their old building on Cajon Street, the YMCA built this new facility at its present location on Citrus Avenue.

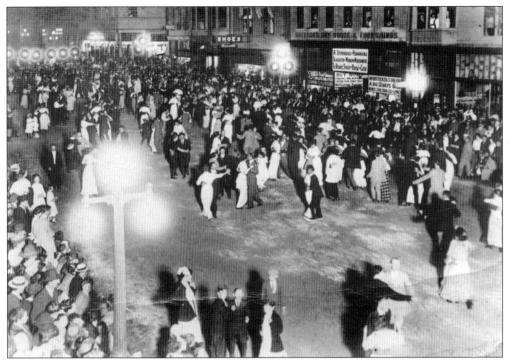

For a period of time during World War I, on occasion, State Street was illuminated in the evening and street dances were held. This postcard is from 1914.

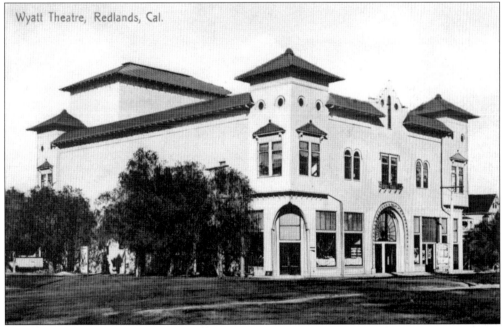

The Wyatt Theater stood on the northwest corner of Orange Street and Colton Avenue. With seating for 1,300 patrons and the fourth largest stage in California, it attracted famous actors, musicians, and theater troupes. Entertainment preferences changed with the introduction of motion pictures. The building was deemed unsafe and was razed in 1929.

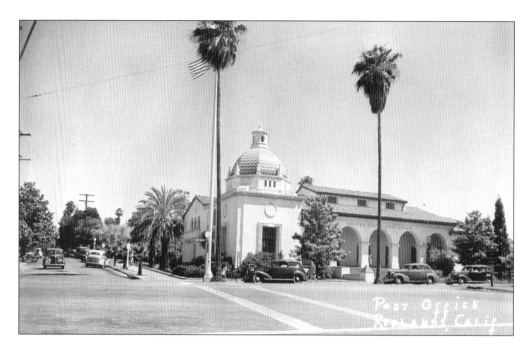

The Redlands Post Office was authorized to be constructed as a federal building in 1933, under the administration of Herbert Hoover. The building was completed in 1934 under the administration of Franklin D. Roosevelt. In the Spanish Mission Revival style, it is recognized as one of the most beautiful post office buildings in the state. It houses the Redlands Post Office Museum, the only known post office museum in the country other than the Smithsonian's Post Office Museum in Washington, D.C. The museum is in the corner room, which was once the postmaster's office.

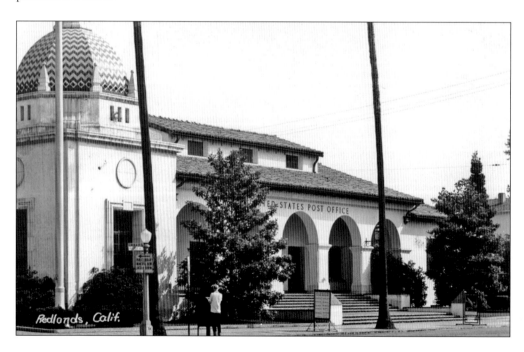

The old city hall was destroyed by fire in 1939. This postcard depicts the new city hall building, which was built at the same location.

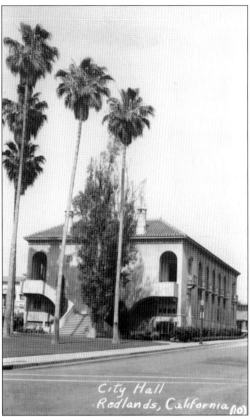

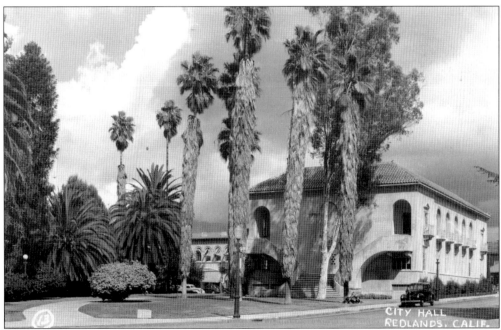

The small park behind city hall on Vine Street is named after the Smiley Brothers. Smiley Park used to encompass 16 acres of land.

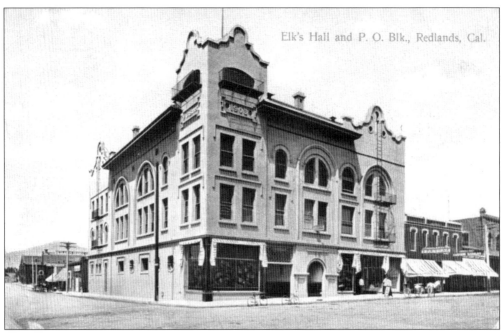

By 1903, the membership of BPOE had grown sufficiently that land was purchased for construction of a new Elks Lodge. Located on the corner of State and Sixth Streets, Elks Lodge No. 583 was constructed.

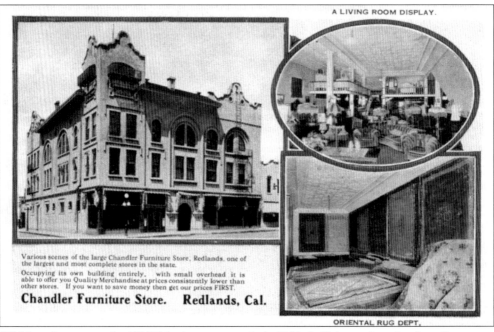

Within a few years, the BPOE had outgrown their 1903 facilities and made plans for a new, larger Elks Lodge to be built at the corner of Third and State Streets. The vacancy was quickly filled by the Chandler Furniture Company, as seen on this card.

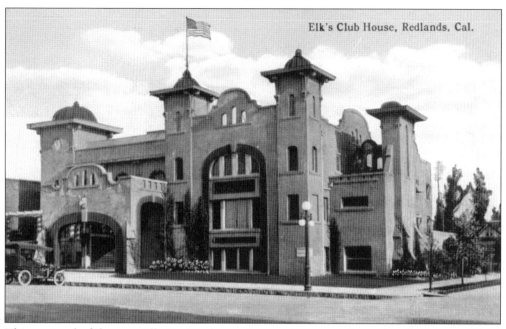

This postcard of the new Elks Lodge shows the greatly expanded meeting facilities on Third and State Streets.

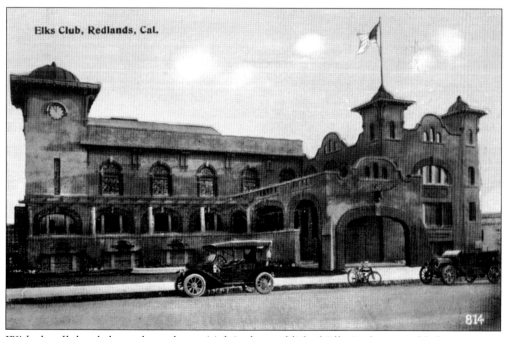

With the elk head above the archway (right), the established Elks Lodge is visible here.

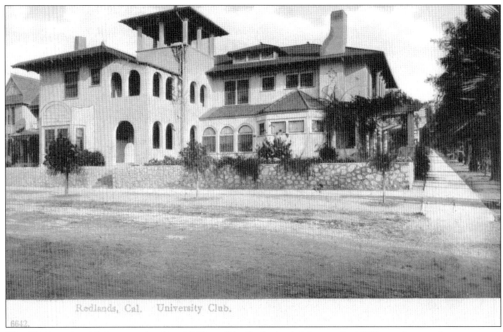

The University Club organized in 1902 and built their clubhouse in 1903 on the southeast corner of Fern and Cajon Streets. Membership consisted of men with a university education, but the group's founding preceded that of the University of Redlands.

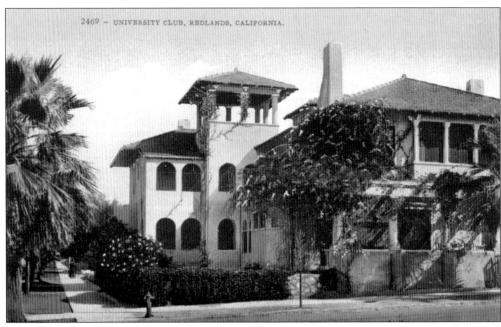

The University Club property was eventually taken over by the American Legion and later became housing.

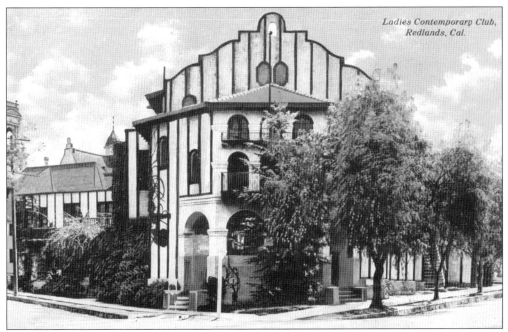

The Contemporary Club was founded by 25 women in 1893. For years, they met in local public halls, but in 1904, they built this Tudor and Mission-style meeting hall on the southeast corner of Fourth and Vine Streets.

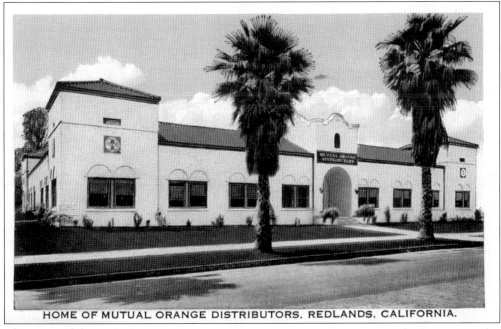

This postcard shows the headquarters of Mutual Orange Distributors on Brookside Avenue. This cooperative, organized in 1906, became the world's second largest marketing and distribution organization of its kind.

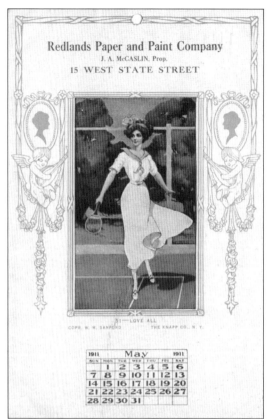

Calendar cards were a favorite advertising tool. This 1911 card, showing a lady tennis player in contemporary dress, was issued by the Redlands Paper and Paint Company on west State Street.

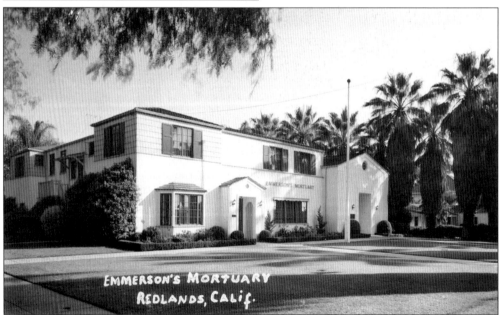

Glen W. Emmerson moved to Redlands as a young man after having apprenticed at Mark B. Shaw undertakers in San Bernardino. By the mid-1930s, he opened his own funeral home in Redlands.

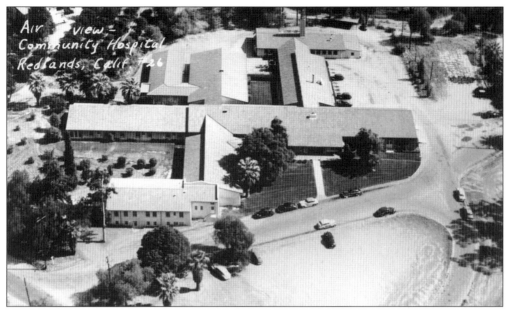

This is an aerial view of the Redlands Community Hospital, taken in 1955. Located at the corner of Fern and Terracina, it occupies the site of the original Terracina Hotel. Redlands Community Hospital celebrated its centennial in 2006.

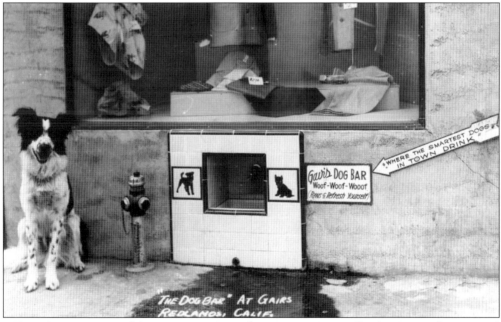

Milton Gair was one of the most prominent businessmen in Redlands. He was known and respected throughout the nation for his views of small business and economics. In the late 1920s, he opened Gair's, a quality clothing store. Originally located on Orange Street, he later moved the store to State Street. This dog bar is the original at the store on Orange Street. The smartest dogs in town drank there, or so the sign said.

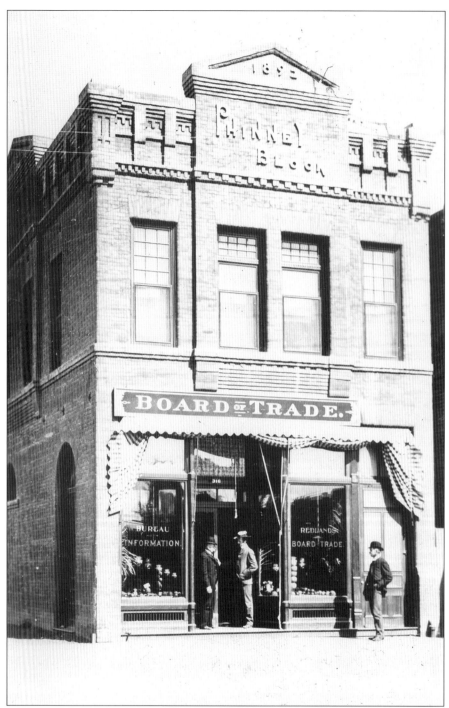

The Phinney Building, located on Orange Street, just north of Redlands Boulevard, was the scene of many celebrations. Home of the Redlands Board of Trade, later to be known as the Redlands Chamber of Commerce, the exterior was often decorated with flags, bunting, and banners to celebrate the Fourth of July or to welcome a visiting president. The Phinney Building is across the street from the site of the old Southern Pacific Depot.

Three

HOTELS AND INNS
COME TO VISIT, AND STAY

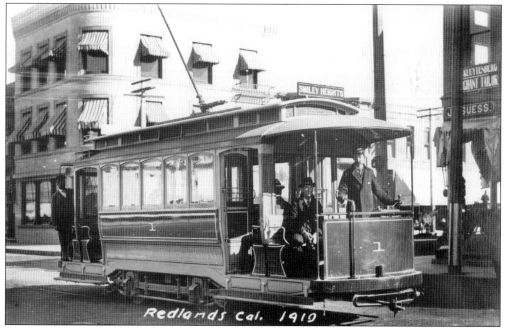

The sign atop this electric-powered streetcar indicates it is bound for Smiley Heights, a favored destination for people visiting Redlands, as well as serving locals wanting to board and be dropped off at stops along the way. The Redlands Street Railway Company was electrified in 1889.

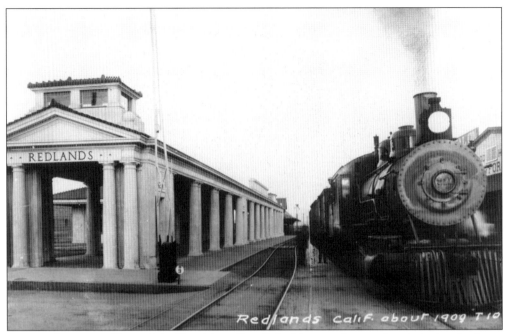

Train enthusiasts will certainly like this well-polished locomotive on the tracks by the Santa Fe station. The station looks pristine and new. Though no longer a railroad station, it is still a landmark favored by photographers and artists.

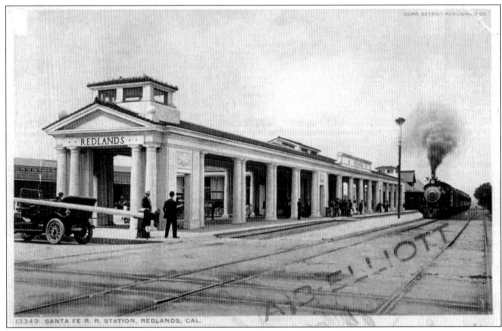

When the railroads arrived in Redlands, so did more people wanting to see this beautiful place they had heard about. Santa Fe Railroad began serving Redlands in 1888. Blowing a bit of smoke, probably for benefit of the photographer, a passenger train pulls into the new 1909 Santa Fe station.

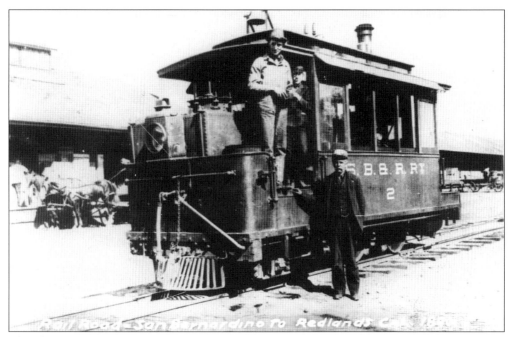

This photo postcard shows narrow-gauge locomotive No. 2 of the San Bernardino and Redlands Railroad Company. The so-called "Dinky" line began operation May 17, 1888, with 10 miles of track on streets between the two towns. The locomotive usually pulled two or three cars and made several trips daily.

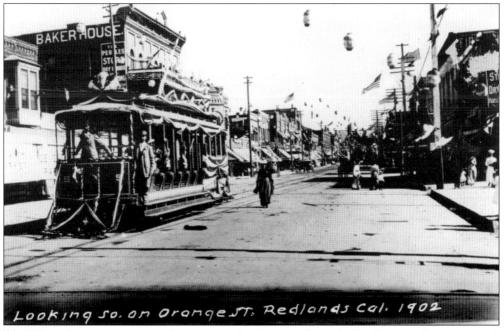

The Baker House, a downtown hotel, opened in 1892 on the east side of Orange Street, situated opposite the Santa Fe Railroad station. The hotel can be seen behind a decorated streetcar and amidst other Fourth of July decorations.

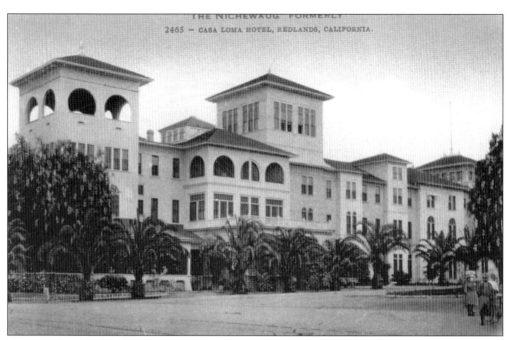

The grandest hotel in Redlands was the Casa Loma, built to replace the Terracina Hotel that burned in 1895. Built almost entirely of California redwood, the Casa Loma opened its doors for business on February 25, 1896. Owned by various proprietors over the years, in 1917 it was renamed "The Nichewaug," also the name of a famous old inn in Petersham, Massachusetts. The unpopular name was soon changed back to Casa Loma.

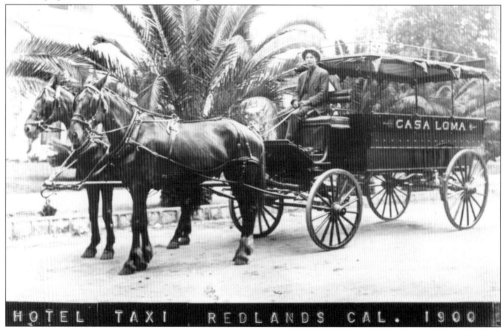

The Casa Loma's own horse-drawn carriage transported guests to and from both railway stations and occasionally on excursions to nearby destinations. Note the cut stone curbs, which are still seen in many of the historic districts in Redlands.

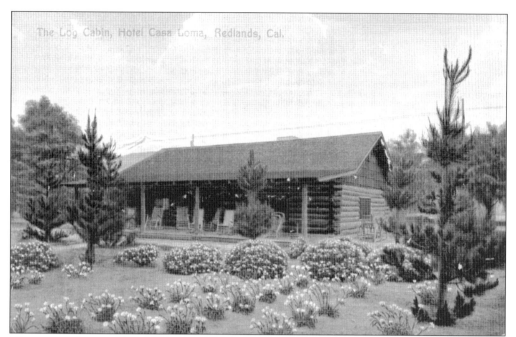

The Log Cabin was no joke. It offered guest accommodations adjacent to the hotel proper, though with the usual hotel amenities. Guests then could say they had "stayed in a log cabin out west." Meals, of course, were served in the hotel dining room.

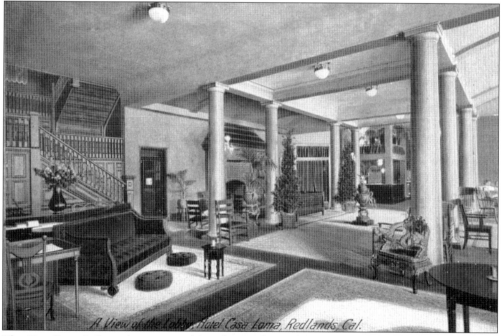

The Casa Loma's front doors opened into large, pleasantly appointed sitting rooms and a grand stairway, as shown in this 1896 view. The Great Depression ended Redlands's greatest tourist days, and the hotel business suffered. The hotel gained a new life when purchased by the university in 1939 to be used as a residence for women students.

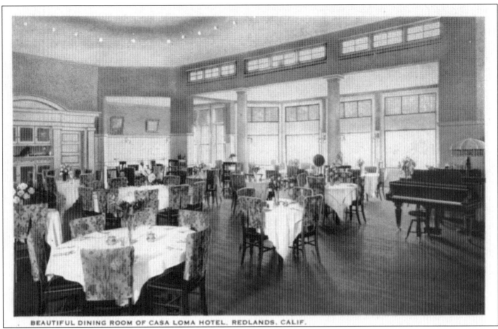

BEAUTIFUL DINING ROOM OF CASA LOMA HOTEL, REDLANDS, CALIF.

The Casa Loma dining room was bright and spacious, with a piano for musical entertainment. When the hotel became University Hall in 1939, the tables were sometimes moved aside for special occasions such as dances, especially to welcome new students. Redlands lost a treasure when the hotel was torn down in 1955.

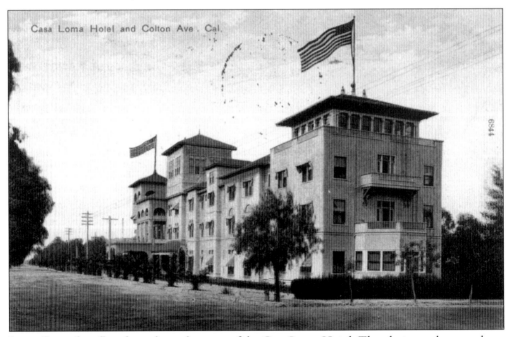

Large flags often flew from the end towers of the Casa Loma Hotel. The photographer may have exaggerated the size of the flags a bit in this 1910 view from the southeast corner. The Wyatt Theater was conveniently located across the street just beyond the hotel from this view.

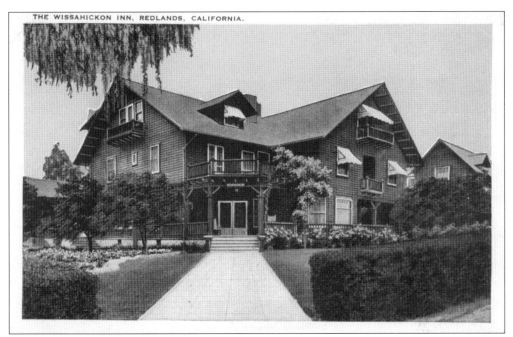

The famous Wissahickon Inn offered accommodations in a more home-like setting than in a typical hotel. The inn comprised several separate housing structures. The name was not native to the Redlands area but was the name of a small stream in southeastern Pennsylvania where Curtis Wells, the owner and builder of the inn, had lived before coming to Redlands.

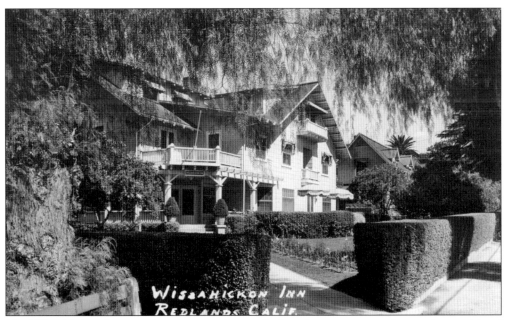

The Wissahickon Inn continued as a rather exclusive place to stay on the southwest side of Redlands until the early 1960s, when its popularity waned and it began to fall into disrepair. It eventually closed, and the buildings deteriorated badly. Purchased by new owners, its refurbished buildings are now being occupied as separate residences.

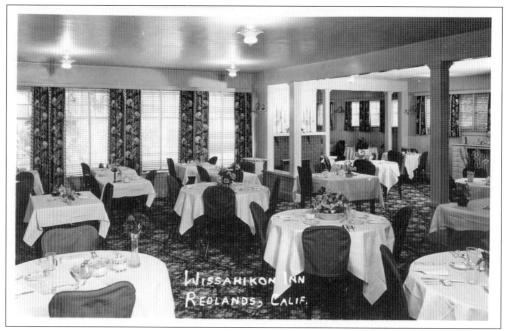

The Wissahickon Inn featured a comfortable and spacious dining room for its guests, some of whom came only for a night or two, while others stayed several weeks. Some eastern visitors even made the inn their winter residence. They might be called "snowbirds" today.

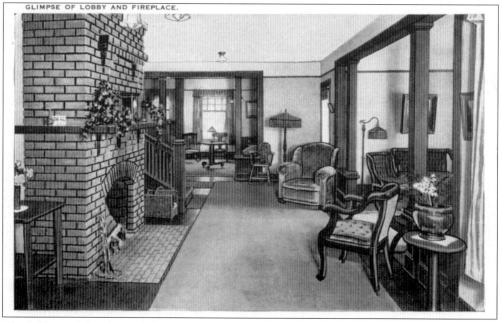

The lobby and fireplace of the Wissahickon Inn offered a warm and comfortable place to sit and read or enjoy a conversation. The inn also had tennis courts on the grounds, and the golf links were not far away.

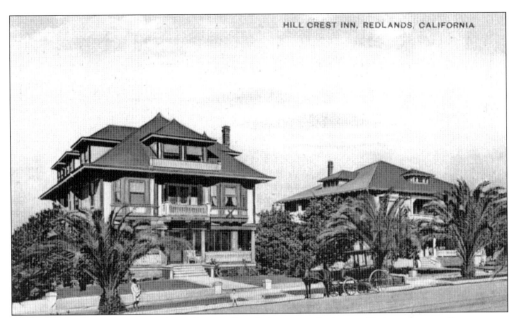

The Hill Crest Inn was another of several such home-style inns offering commodious rooms and beautiful surroundings. The picture appears to show two houses, but they are joined in a U-shape as a single building with a garden in the center, as described by the sender on the message side of this card.

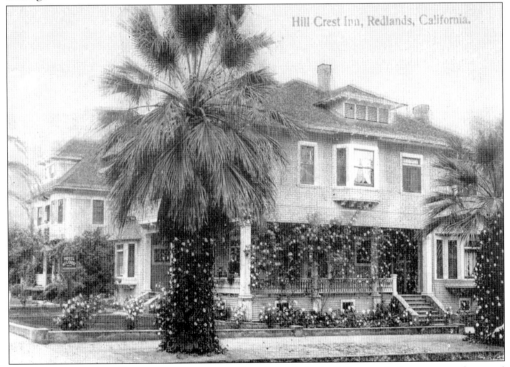

Another view of Hill Crest Inn attests to the size of the building and shows one of several porches where guests could enjoy the salubrious weather for which so many people are attracted to Redlands.

LA POSADA HOTEL, REDLANDS, CALIFORNIA

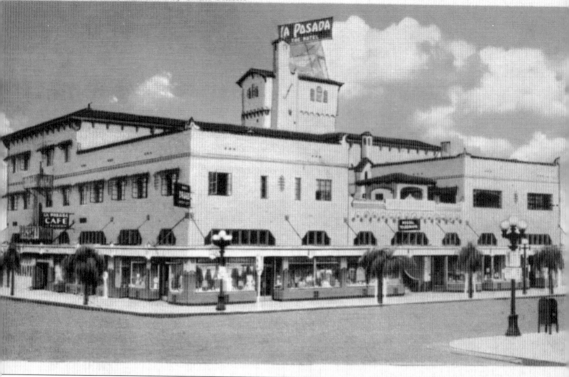

The La Posada Hotel was built by Arthur C. Gregory in the 1930s. The modern-style hotel also housed a drugstore, gift shop, and other conveniences, plus amenities such as steam heat, air-cooled rooms, private bath, and free parking lot. Rates were $2 single, $3 double, and $3.50 for twin beds. Notice the new triple-globe street lamps.

Four

THE SMILEYS
A HERITAGE OF
VISION AND GENEROSITY

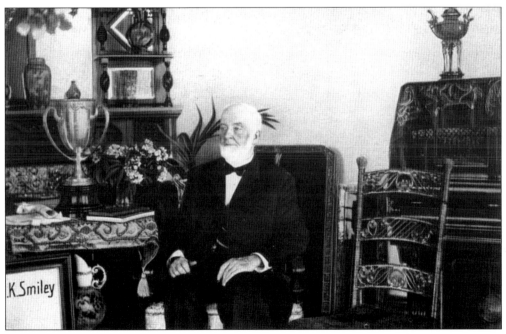

A. K. Smiley is seated beside the "loving cup" given to him on his 80th birthday by the "citizens and children" of Redlands as a token of affection and respect. The Smileys were Quakers, members of the Society of Friends, as evidently was the sender of this postcard, who wrote on March 4, 1912, "We have been in this beautiful Smiley home. Thee knows of their notoriety as Friends. Particularly interested in Peace & Temperance. Very truly thy friends, Lillie & Anna Hoopes."

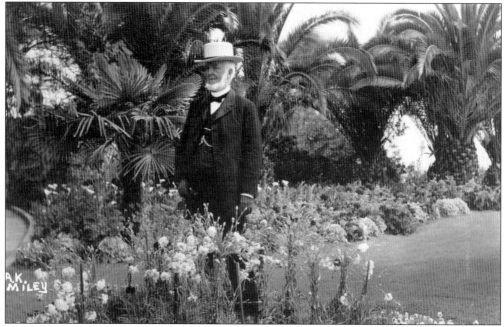

A. K. Smiley is pictured standing in the garden of his estate, dressed in the conservative style of the Quakers, though allowing narrow lapels on his coat and a gold watch chain.

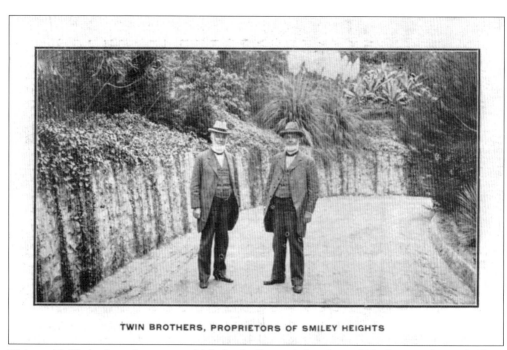

TWIN BROTHERS, PROPRIETORS OF SMILEY HEIGHTS

This card is likely the only one on which the Smiley twin brothers, Alfred H. Smiley and Albert K. Smiley, are shown together. Perhaps Alfred was camera shy, though he seems to have been on boards and in important positions of influence, while Albert is the one whose name appears more often. One seemed to work behind the scenes, while the other was more in the public eye.

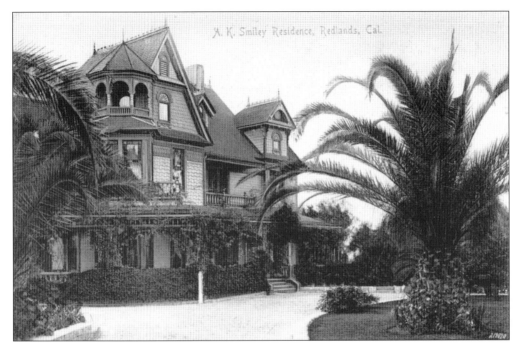

This scene shows the A. K. Smiley residence in Cañon Crest Park. One of a series of such photographs of stately homes, they were often hand colored for consumer appeal.

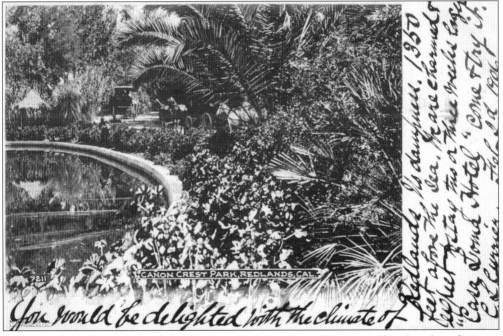

Lush growth in Albert Smiley's Cañon Crest Park is pictured here, as well as the edge of Mirror Lake. The handwritten message says, "You would be delighted with the climate of Redlands, no dampness. 1350 feet above the sea. We are charmed & expect to stay two or three weeks longer. Casa Loma Hotel, come & try it. E. L. Currier, Feb. 2d, 1906."

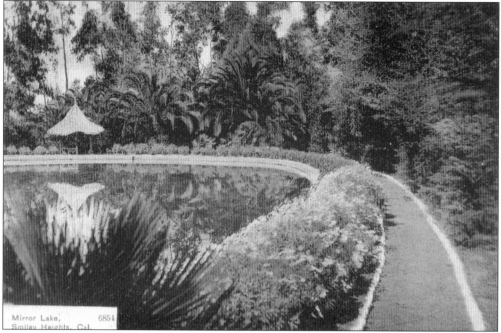

Mirror Lake, in Smiley Heights, was set in the midst of a horticultural wonderland of flowers and trees, with pleasant paths for walking. Protected from breezes by the trees, the surface of the lake often offered perfect reflections, as pictured here.

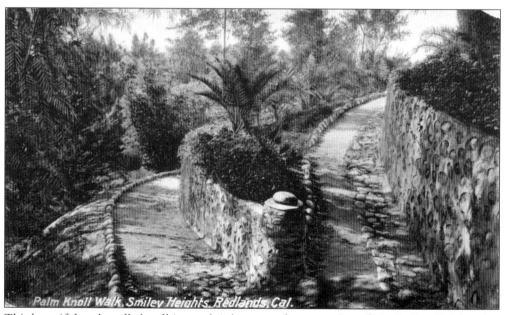

This beautiful rock-walled walking path is but one of many such trails in Smiley Heights that delighted visitors from near and far. People arrived by train and were met by carriages to be taken to the park. The last vestiges of the park that remained have now been covered by the development of upscale houses.

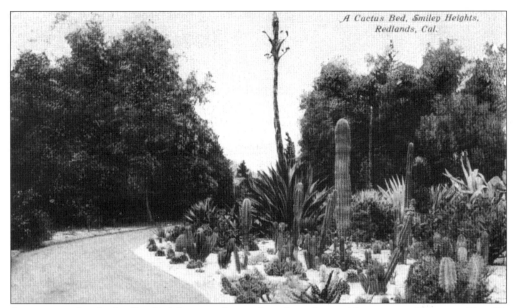

A cactus garden in Smiley Heights was the perfect place for people to see and learn to identify various types of cacti from the California and Arizona deserts. The tall round one in the center is a saguaro (sa-hwa-ro). Behind and to the far right is an ocotillo (o-ko-tee-yo), and the very tall one with its blossom tip out of view is the so-called "century plant," more properly known as agave (ah-gah-vay). Its blossom spikes can reach up to 25 feet in height.

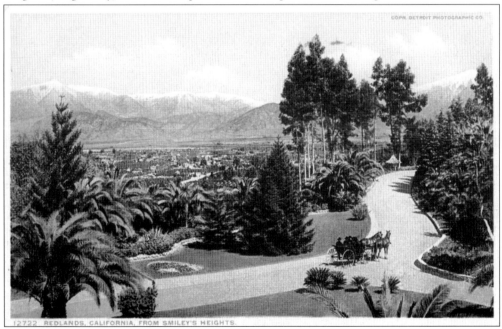

Horse-drawn carriages took visitors for rides on carefully groomed roads through the park. This carriage appears to be carrying four men dressed in dark suits and black hats. The snow-covered pointed peak of Mount San Bernardino is visible at far right. A line directly west from this peak is the "base line" of real estate in Southern California. The line follows Base Line Avenue in San Bernardino and other avenues all the way to the sea.

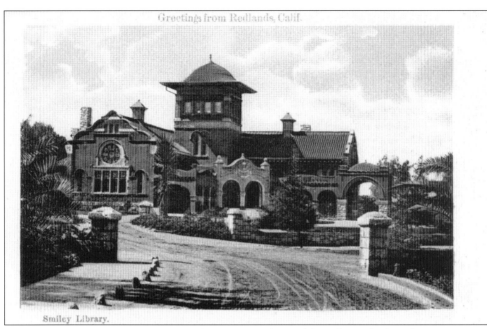

A very early picture postcard shows the A. K. Smiley Public Library before the east wing was extended, the two wings of the L-shaped building being equal at that time. This picture, taken from the east-side drive, also shows the circular drive to permit horse-drawn carriages entering from the west to depart the same direction from which they came.

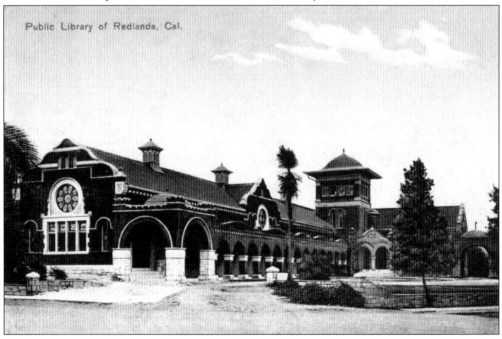

This 1909 card shows the greatly extended east wing and realignment of the driveway close to the building. The barely literate message to someone in Highland complains, in her exact words, "Dear Auntie why don't you ever come over and see me the devil with the rest I am homesick to see you. Come over I will see you some day may be for I die write to me please. Emma R."

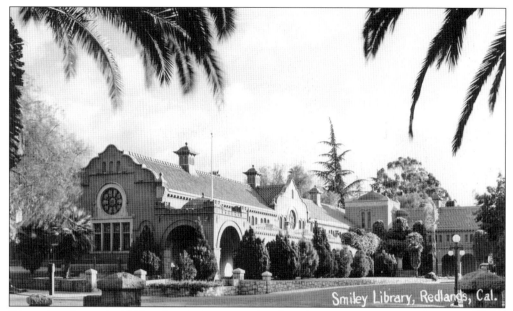

Discussions began in 1933 and again in 1938, when board president Clarence White mentioned there were alkali stains through the red paint and that the color did not harmonize with surrounding buildings. The building was painted white in 1939. The tower had been removed in fear that it could fall during an earthquake. The tower and the brick color have since been restored.

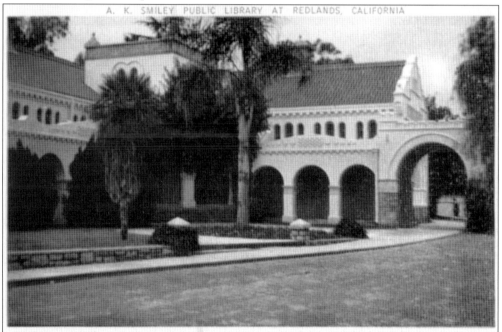

The 1933 Long Beach earthquake raised issues of the safety of public buildings and resulted in the Field Act and its range of building safety regulations. The tower of the A. K. Smiley Library was removed in 1933. Cost of removing the 14-foot-high structure was only $516. The removal revealed serious support problems due to the weight of the structure. The tower was rebuilt to modern standards in 1999.

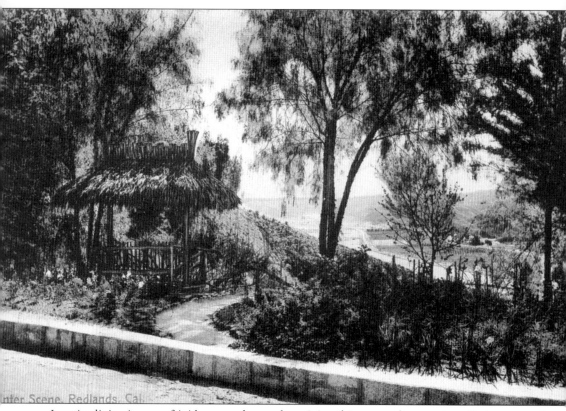

Imagine living in some frigid snowy place and receiving this postcard portraying a "winter scene" in Redlands, with this view from Smiley Heights. The tinted card shows rich deep greens and bright-colored flowers. A palm frond–covered shade hut offered walkers a resting place. Local residents called the huts "spooners." Perhaps they had reason to know.

Five

A Place of Beauty and Enjoyment

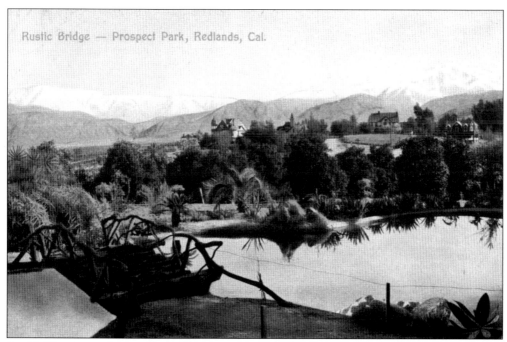

An idyllic view of a Redlands winter scene is a feast for the eyes, with a rustic bridge across a mirror-like pond and snow-covered mountains. In the distance, at center, are verdant hills, beautiful homes, and a variety of trees. The photograph was taken in Prospect Park.

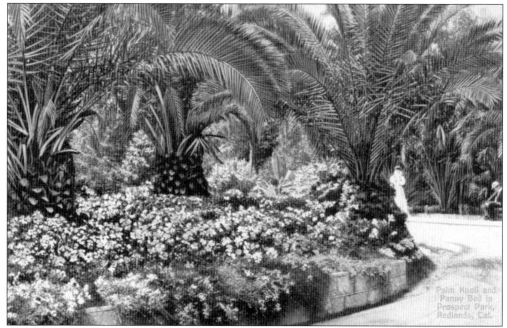

A white-clad young woman walks amid the trees and a bed of pansies on Palm Knoll in Prospect Park. Cut stone walls, broad paths, and carriage roads outline flower beds and a variety of plants and trees. Prospect Park of today features an outdoor theater and a former carriage house that has become an attractive place for social events.

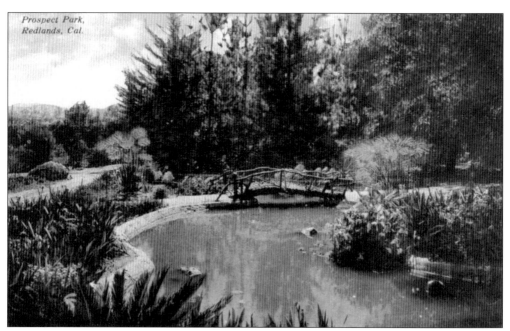

A rustic footbridge spans a narrow part of a pond in Prospect Park, surrounded by a variety of flowering plants, pines, and palms. At the left, mountains are visible in the distance and a road leads down to the town.

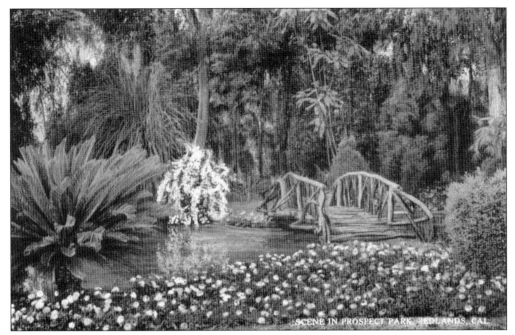

Another and somewhat later view of the same footbridge shows much more mature trees and bushes, with a stunning display of color on the original card. While the ponds have become planted beds, the trees and lawns of today's Prospect Park still offer a cool respite from summer heat.

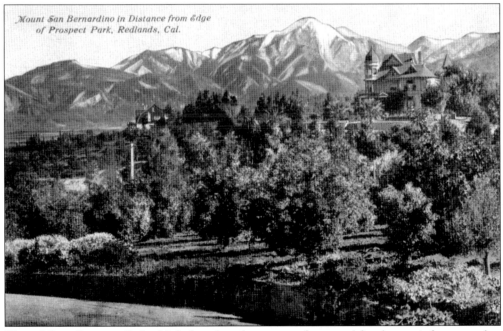

Viewed from Prospect Park, this lush and verdant scene of trees and fine homes is foreground to Mount San Bernardino, which dominates the valley and, in the winter, is beautiful in its snowy raiment. The mountain and valley were named by the Spaniards in honor of St. Bernardine of Siena.

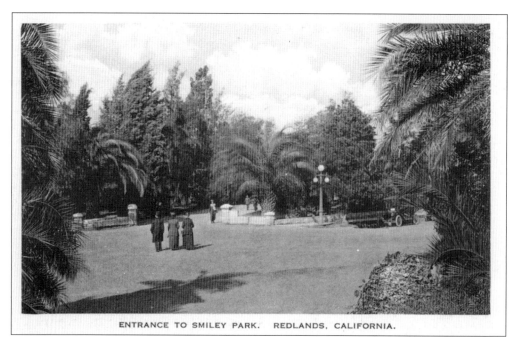

ENTRANCE TO SMILEY PARK. REDLANDS, CALIFORNIA.

Smiley Park, in downtown Redlands, encompassed the A. K. Smiley Library and what was then known simply as the Smiley Park Amphitheatre. These people entering the park hardly seem dressed for the occasion, with top hat and coat and long dresses and hats. Barely visible on the right is an automobile of perhaps mid-1910s vintage.

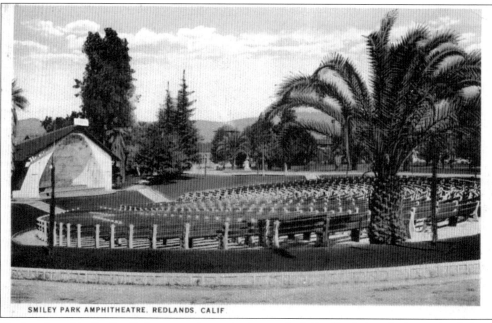

SMILEY PARK AMPHITHEATRE, REDLANDS, CALIF.

The bandstand in Smiley Park was not located where today's Redlands Bowl is but rather behind the library in the place where the Lincoln Shrine now stands. The scene pictured here features a new shell farther west, in the present bowl location, and with new permanent seating. Smiley Library is in the center of the picture.

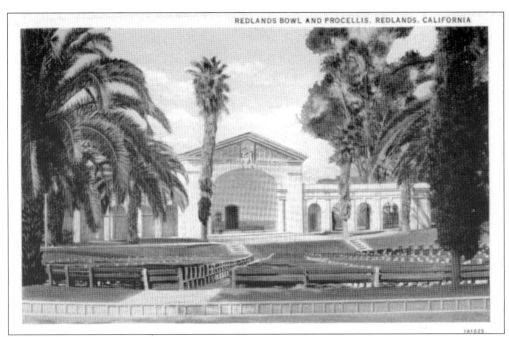

No longer a mere band shell, the present Redlands Bowl and Prosellis was dedicated in 1930. Many people remember their high-school graduation in this place. The bowl is home to the professional and community music, dance, and dramatic concerts presented by the Redlands Community Music Association, founded in 1923 by Grace Stewart Mullen.

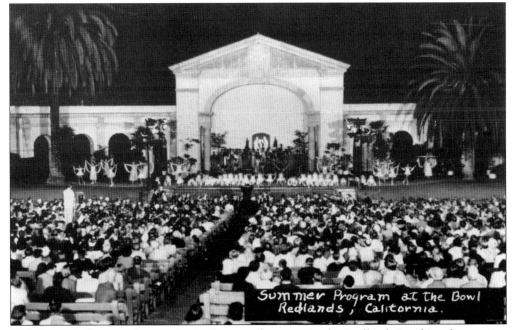

This is a typical scene of a crowd enjoying a performance in the Redlands Bowl in what appears to be a ballet presentation. The bowl seats over 5,000 people, and it is often full to overflowing with people coming from far and near to enjoy the twice-weekly programs in the open air under the stars.

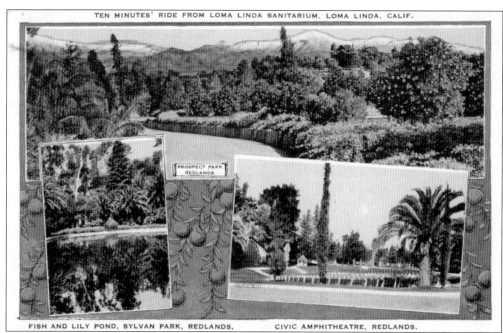

This early 1930s montage of pictures of Redlands was sold in neighboring city Loma Linda. Many people came to Loma Linda for its excellent health and medical facilities. Their visit to the area could certainly be enhanced by visits to the parks and summer evening entertainment available next-door in friendly Redlands.

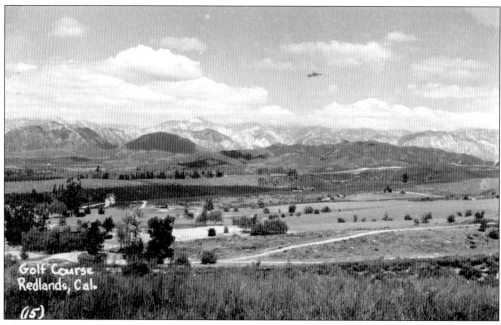

This golf course, featured on a card dated 1955, looks rather rustic in comparison to what we expect golf courses to look like today. Still it developed into a very fine course and club, of which people can be proud to be members.

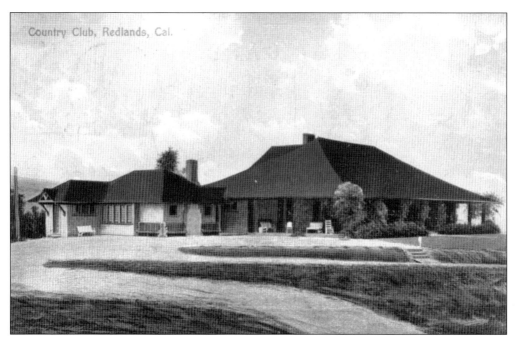

This postcard shows a very early version of a Redlands Country Club clubhouse. Redlands already boasted the finest golf course for miles around. Many Redlands residents and people from the surrounding area are members of the country club and enjoy the golf course, the fine restaurant, and excellent facilities for social occasions.

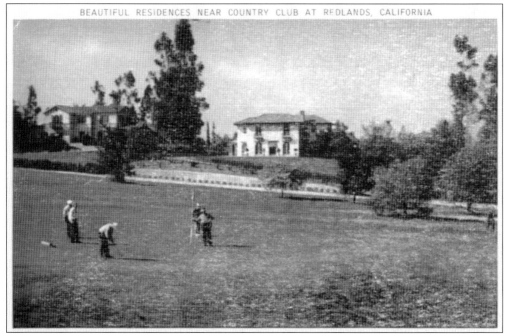

Beautiful homes surround the Redlands Country Club, as shown here, and most areas of the course provide stunning views of the mountains, especially in the mild temperatures and clear air of winter and spring.

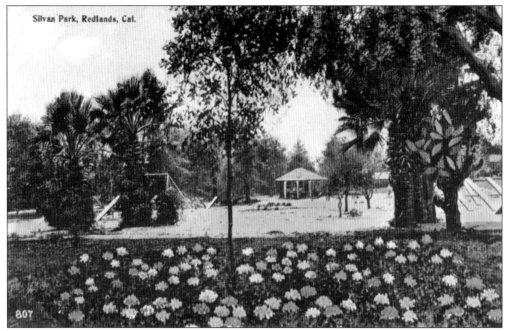

Just beyond this flower garden in Sylvan Park is a large playground with swings and other play equipment especially for young children. A wading pool was also a popular place for the little ones on a summer day.

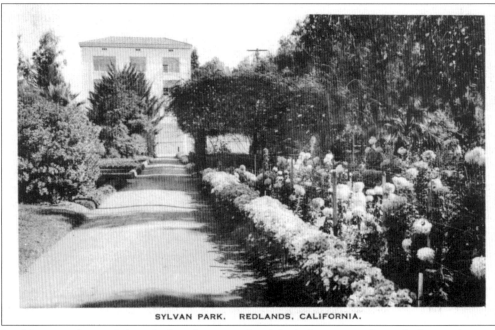

Looking east along a Sylvan Park pathway, to the right is the rose garden, which was always a riot of color and imparted a wonderful scent in the air every spring. The building beyond the park is Duke Hall of Science, on the University of Redlands campus.

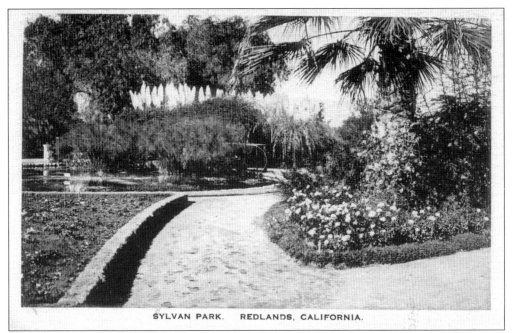

Sylvan Park has changed over the years. These stone curbs and fish and lily ponds are gone now, but it is still a wonderful place for children to play and run. Many groups and families still enjoy the large picnic area, and the Independence Day celebration brings out hundreds of people to hear the Fourth of July Band play.

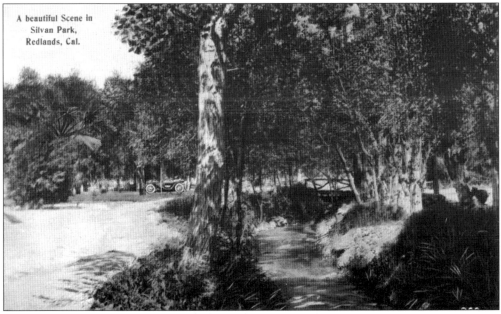

The beautiful Zanja, the irrigation ditch dug by local Native American labor for the mission estancia nearly two centuries ago, is shown as a pleasant stream flowing through Sylvan Park. The stream is still there, at least when there is some rain, and it can be a mighty flow in a very rainy season.

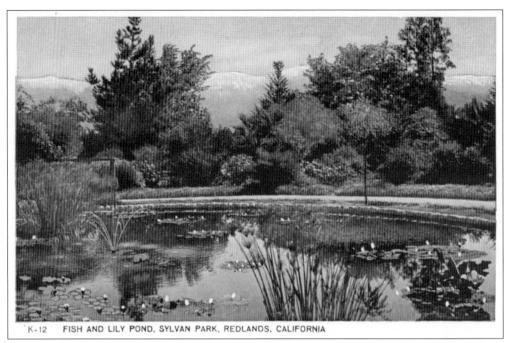

K-12 FISH AND LILY POND, SYLVAN PARK, REDLANDS, CALIFORNIA

The Sylvan Park ponds were delightfully beautiful, especially against the backdrop of blooming trees and snow-covered mountains. Who could resist taking a picture or sitting down to sketch this scene?

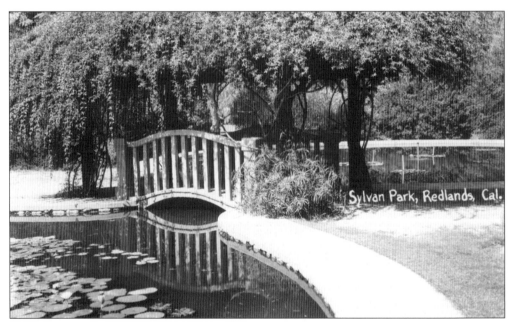

The beautiful fish ponds in Sylvan Park, with lilies floating in them and paths around them, were delightful and enjoyable in their time. The danger to unsupervised children, however, was too great a risk, and maintenance costs were too high. They remain a pleasant memory.

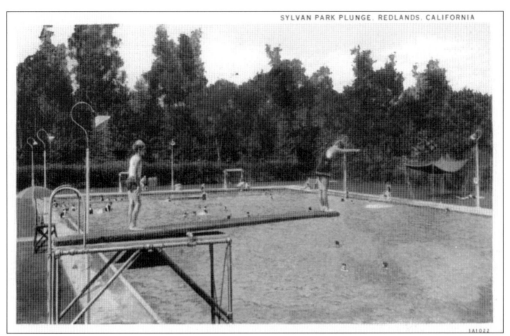

Sylvan Park Plunge is no more, but for many years it was a popular place, especially on hot summer days. That was before so many homes had pools in their backyards. It was removed about 1950. A campaign was launched a few years ago to collect "pennies for the plunge." A nice idea, but pennies could never do it.

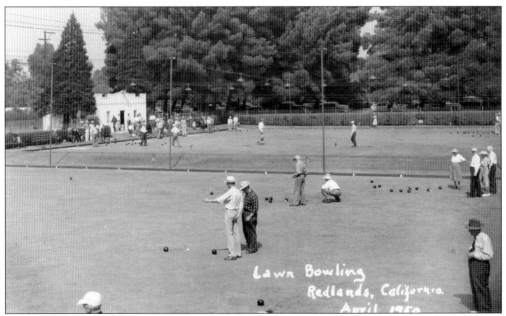

Lawn bowling sounds very British, and it is, but the sport has been a part of Redlands for a very long time and has many enthusiastic participants. The picture shown here was taken in 1950. The bowls green is at the south edge of Sylvan Park near University Street.

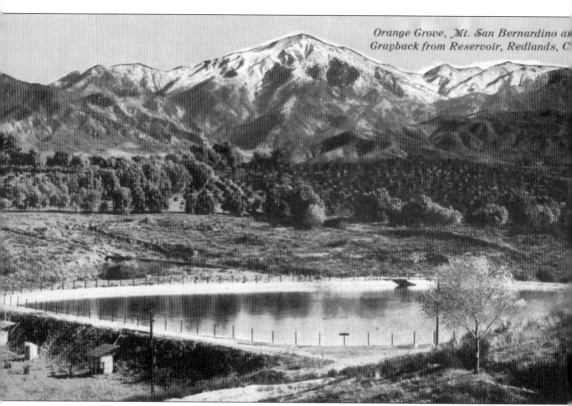

A reservoir does not sound very picturesque, but consider this view on a 1911 postcard of a Redlands reservoir with 10,300-foot Mount San Bernardino in the center and 11,452-foot Mount San Gorgonio (Old Greyback) to the right. Add to that the orchards, green hills, and water, and it is indeed picturesque.

Six
A CITY OF CHURCHES

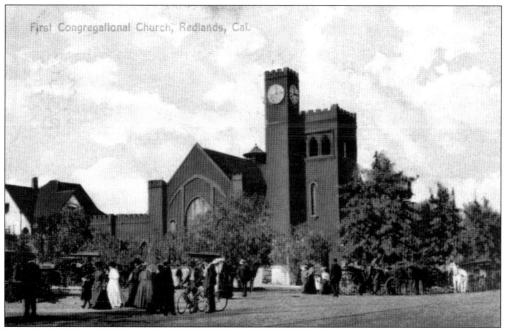

First Congregational Church was the first church organized in Redlands. Its first building, on the corner of The Terrace and Church Street, was dedicated in 1883. The congregation outgrew its small wooden structure and, in 1890, dedicated its fine new brick building at Olive and Cajon Streets. Later adding some Tiffany windows, the church remains essentially as it was over 100 years ago.

First Congregational Church is pictured along unpaved Cajon Street, with the YMCA building in the distance. The church bell still tolls the hours, as it has for more than 100 years, though the original wind-up mechanism was long ago replaced by an electrical system.

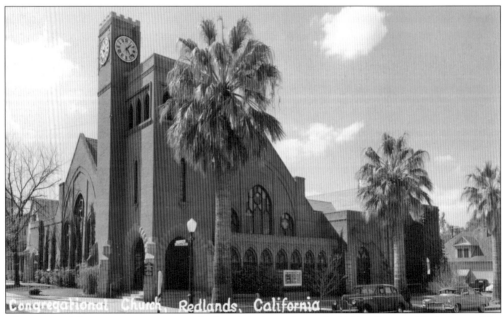

This view of the First Congregational Church is from the early 1950s. A magnified view of the original card revealed that the Reverend Mr. Churchill was then pastor. Note the style of street lamps then in use in Redlands.

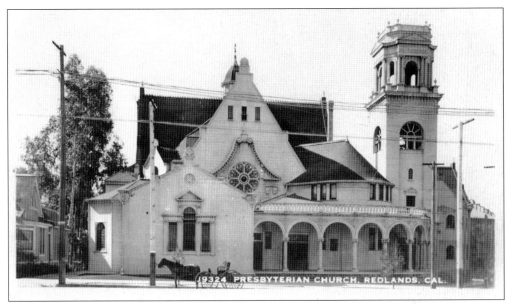

A horse-drawn carriage waits in front of the First Presbyterian Church in this excellent view of the building when it was only a few years old. The streets, of course, were still unpaved, which was a problem in rainy weather but a good thing when one still depended upon horses as the primary means of travel around town.

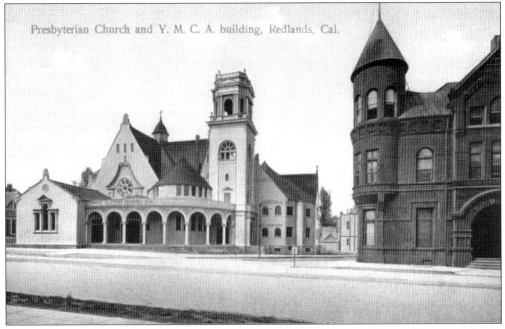

The First Presbyterian Church on Cajon Street served almost 60 years longer than when shown on this 1908 postcard. In 1967, the building was scheduled to be razed for a new structure, but not in the manner it happened. An arsonist torched this and the Methodist church on the same night. The YMCA building to the right had been destroyed by fire in 1939. Information on the card cites Redlands, "the home of the orange," as having a population of 12,000 and property valuation of $16 million.

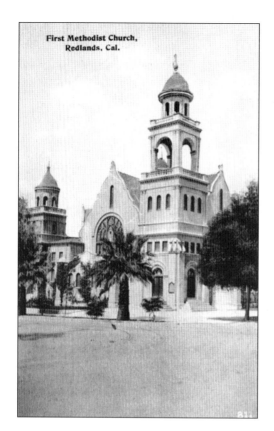

Most people who remember this 1904 First Methodist Church building will recall the tall tower, but take note that there were two towers. The northern one was not as tall as the main tower, but its height gave design balance to the building.

First Methodist Church, organized in 1887, built this towered structure in 1904 at the corner of Olive and Cajon Streets. For many decades, its tower chimes intoned hymn tunes over the town each day at noon, following the noon bell from the Congregational church. This church building and the nearby Presbyterian church burned the same terrible night in 1967, the result of arson.

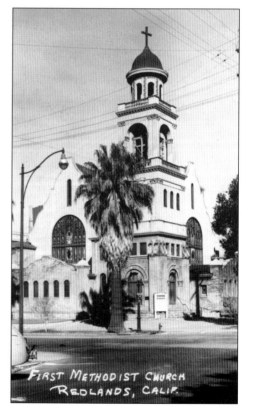

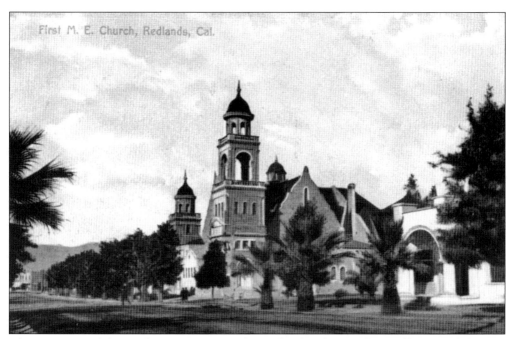

This view toward the north on Cajon Street shows the churches at what is affectionately known as "Holy Corners." The white building to the right became the YWCA.

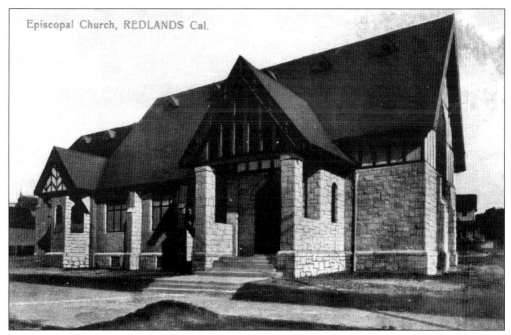

Trinity Episcopal Church, on Fourth and Fern Streets, built of cut stone, appears to have just been completed. This 1904 church building was the third building and location to serve the congregation since it began as a mission church in 1887. The church has several very fine stained glass windows, most notably the large west window.

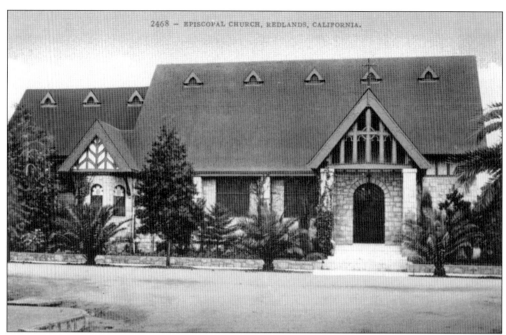

This view of Trinity Episcopal Church shows the plantings now well established but the streets still unpaved. The church celebrated its 100th year in this building in 2004. It houses an excellent pipe organ, and the church is well known for its music.

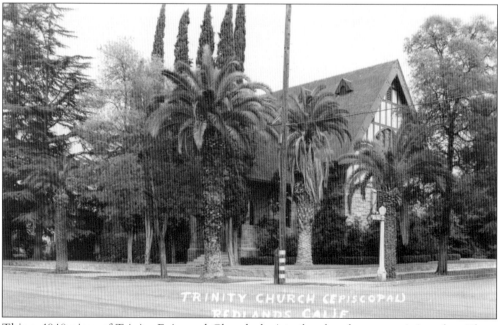

This *c.* 1940 view of Trinity Episcopal Church depicts the church more as it is today. These doors opening to the north are not the main entrance, however, but rather the corresponding doors on the south side, which open upon a large enclosed garden.

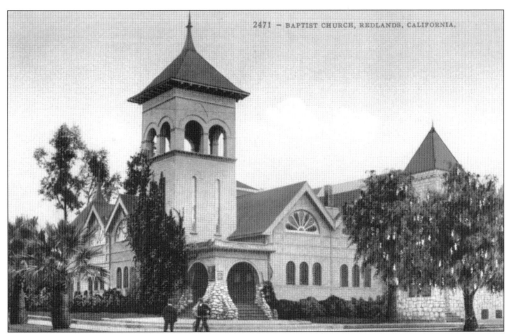

The First Baptist Church dedicated this building on December 27, 1896, at the intersection of Olive and Cajon Streets. There were 1,100 people present for the occasion. The building served that congregation until 1951, when it was razed and a new building constructed on the same site. The building seen to the rear at far right still stands.

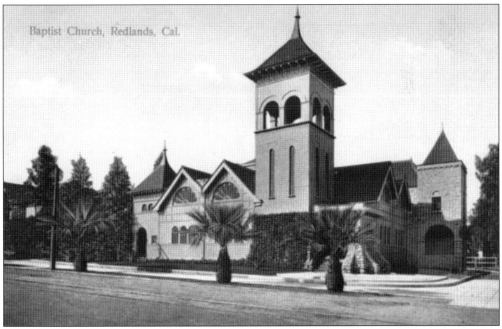

A growth of ivy softens the sharp edges of the church's "new" look in this 1909 postcard view. Forty-two years later, a new generation of members would feel the need for yet another new building more adequate for the needs and the vision of people of the mid-1950s.

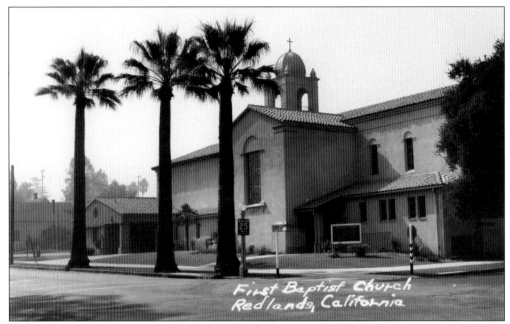

The old structure having been razed, the First Baptist Church worshipped in a large room in another of its buildings until this fine new church was completed in 1953. With the leadership of the pastor, Dr. Frank Fagerburg, formerly of First Baptist Church of Los Angeles, the church soon filled its new building.

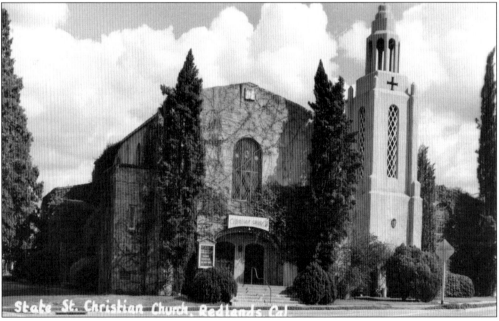

State Street Christian Church was a landmark on Highway 99, now Redlands Boulevard. It stands today, though occupied by a different denomination. One of its early ministers was novelist Harold Bell Wright, author of *The Winning of Barbara Worth* and *The Eyes of the World*, among others. Some Redlands folk became upset when a few of Wright's characters too closely resembled themselves.

Fr. Thomas Fitzgerald celebrated mass in the Wilson and Berry Building, at the corner of Orange and Colton, beginning in 1894. Land was purchased on Olive and Eureka Streets, and building began. The Church of the Sacred Heart was blessed on January 5, 1896. Its steeple was 63 feet tall. A newer and modern Sacred Heart Church stands there now, built in 1964.

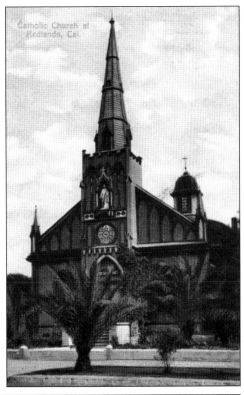

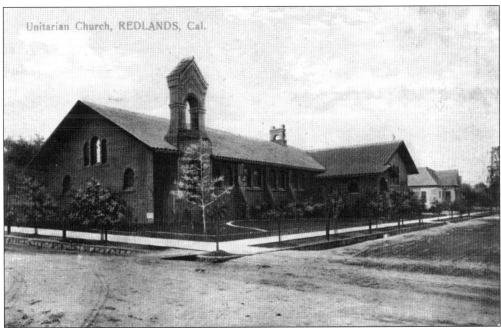

The Unitarian church on Clark Street looks much the same today as on this 1911 postcard. No longer serving a Unitarian congregation, this fine brick building has served a variety of religious groups over the years. This view shows the streets not yet paved, but the cut stone curbs are already in place.

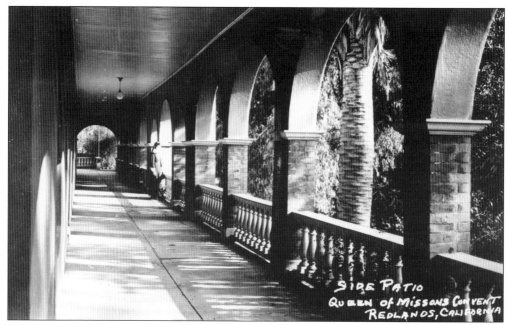

For some years in the mid-1900s, the Burrage residence became the Queen of Missions Convent for a Roman Catholic religious order. While not evoking the religious aspect of the convent, this postcard shows an unusual view from the inside of the colonnaded veranda surrounding the house.

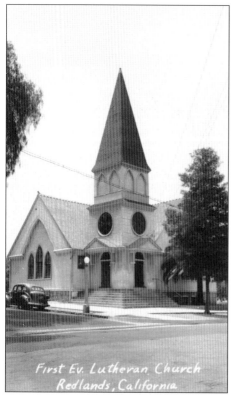

First Evangelical Lutheran Church was located on East Olive Avenue. When the congregation built its current church at the corner of San Mateo and Cypress Streets, they were happy to be able to preserve the old church. It was relocated behind the San Bernardino County Museum, near the also relocated "Edwards Mansion," where it serves as a wedding chapel.

Seven
EDUCATION
THE KEY TO THE FUTURE

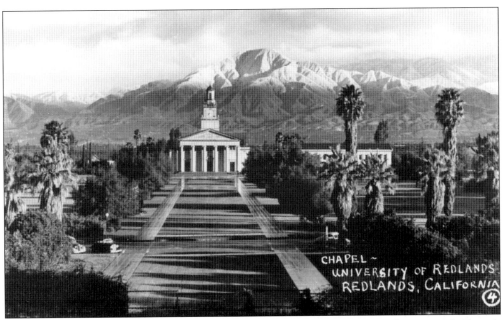

Snow-covered Mount Harrison is the backdrop for this 1950s view of Memorial Chapel. Dedicated in 1927, it hosted weekly chapel services in the early years. The interior centerpiece is the Beatitudes window. The chapel houses the four-manual Cassavant organ and is the venue for the Redlands Symphony Orchestra and (since its inception in 1947) the annual Christmas presentation "The Feast of Lights."

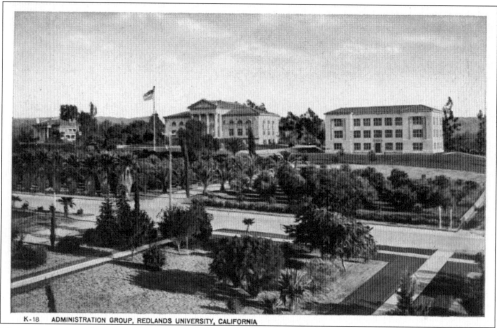

This unusual early campus view shows only three buildings on the hill: the Administration Building (center), Duke Hall of Science (right), and Knoll Hall residence for women (left), which sometime later was moved for the construction of the Hall of Letters. It became the president's residence for many years and is now Alumni House. The garden in the foreground has been a dormitory since 1920.

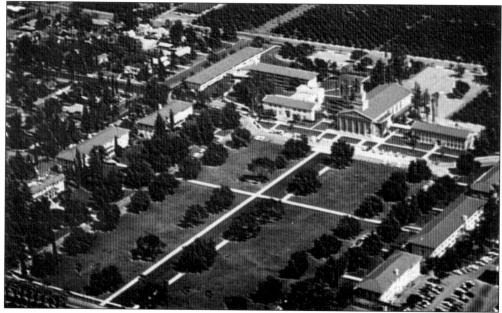

Founded in 1907, the University of Redlands campus is pictured here on a more recent postcard of an aerial view of the Quad and surrounding buildings. To the far left, upper left, and far right are dormitories. The Memorial Chapel is at upper right, flanked at left by Watchorn Hall, housing the School of Music, and the Fine Arts building at right.

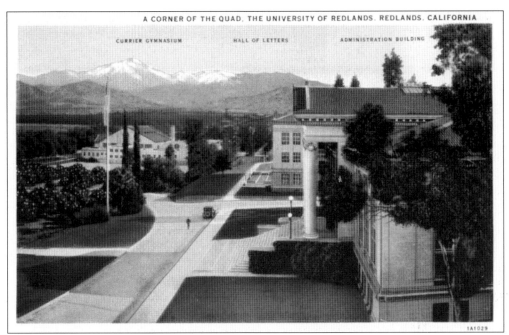

Titled "A Corner of the Quad," this is actually a view of the Administration Building near right, the Hall of Letters beyond, and Currier Gymnasium at center left. Above the flag is 10,300-foot Mount San Bernardino. Printed information on the card stating student body as 600, together with the vintage car, pegs this scene as early 1930s. The photographer dotted in oranges on the trees at left, but size comparison suggests they would be as large as basketballs.

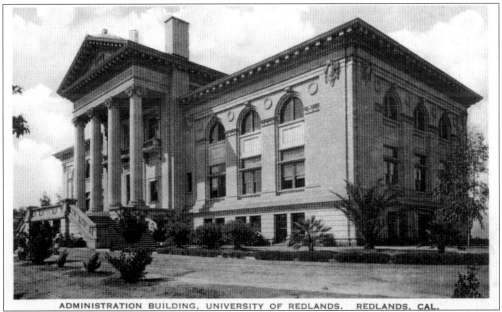

This early photo card of the Administration Building shows the south face of the building, away from the Quad. With the exception of the steps, the two faces of the building are exactly the same. Some suggest that is because it was still undecided whether the campus would develop to the north or south.

85

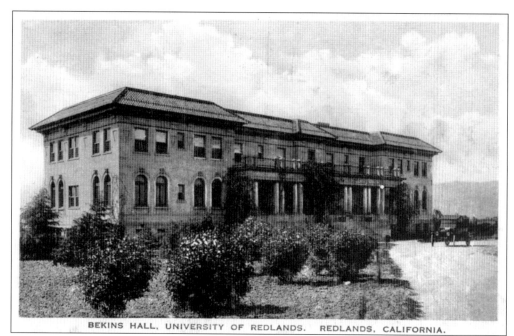

BEKINS HALL, UNIVERSITY OF REDLANDS. REDLANDS, CALIFORNIA.

Bekins Hall, the first residence hall at the university, was the generous gift of Mrs. Martin Bekins, of Bekins Van and Storage. This *c.* 1920 view shows a driveway curving up to the front steps. Bekins Hall housed males until the first men's dormitory, California Hall, was completed.

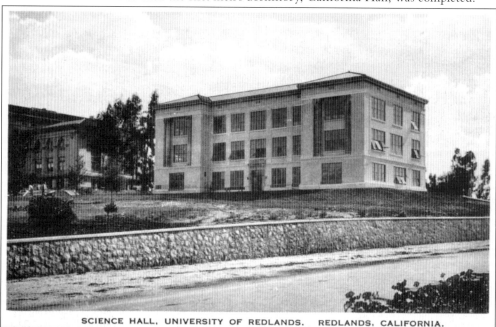

SCIENCE HALL, UNIVERSITY OF REDLANDS. REDLANDS, CALIFORNIA.

Duke Hall of Science was named for faculty member and principal donor Victor LeRoy Duke, who taught 12 years at Shurtleff College before coming to Redlands. The location had originally been planned to be a fine arts building. This *c.* 1930s view from University Avenue shows the Administration Building at far left. Note the fine river stone wall in the foreground along University Street.

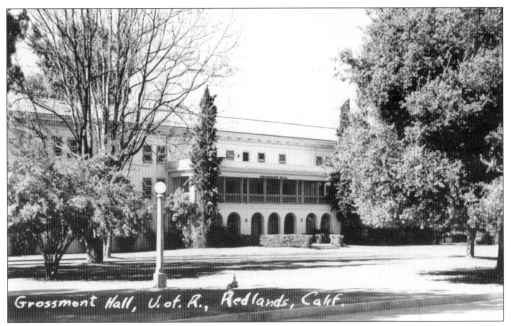

A late-1930s view of Grossmont Hall, a women's residence hall, shows the enclosed, screened-in upper porch, which was undoubtedly a good place to be in the hot days and evenings of late spring or in September. In those earlier years, none of the campus buildings were air-conditioned.

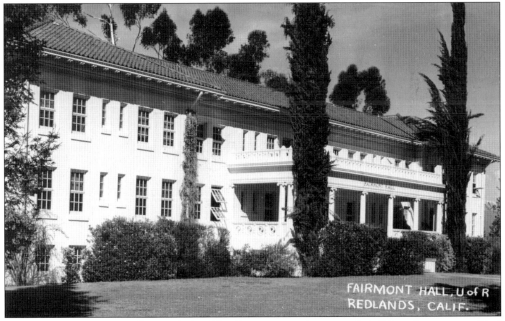

Money for Fairmont Hall was pledged by "an unnamed eastern lady," but she was troubled when the cost soared to $75,000. Since she had also wished to furnish the dormitory, the total cost would come to $85,000. Fairmont Hall, completed in 1920, was the second dormitory designated for women, Bekins Hall being the first.

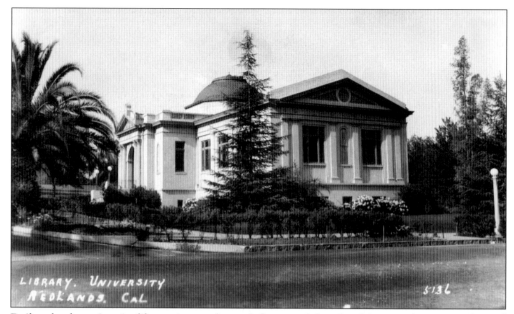

Built to be the university library, it served as such for several decades. It has now been reconfigured for classrooms and faculty offices and named Larsen Hall, for alumnus, trustee, and benefactor Ernest "Ernie" Larsen. Its proximity to the Peppers Art Center also allows some basement rooms to be used for graphics workshops.

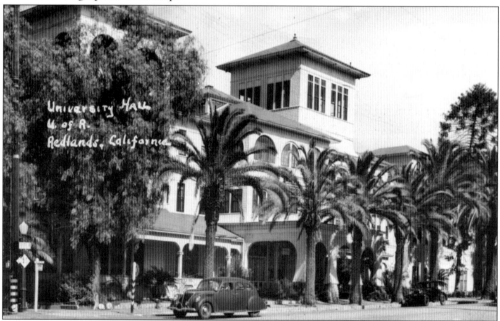

The former Casa Loma Hotel was purchased by the university in 1939, and the fine old building became a residence hall for women, University Hall. The Bulldog Bus ferried women from "U Hall" to the campus a mile away. The bus driver was Chauncey Crum, pictured on the cover, fourth from the left. The alternative transportation system was to wait across the street in the shade of a tree for a ride, as campus men often plied that route hoping to meet some nice young women.

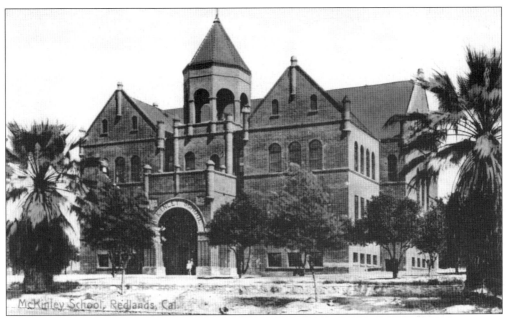

People moving to this area from eastern states built schools as they thought they ought to be—stately and important looking, substantial brick buildings, usually with two floors and a basement. They knew little of the effect of earthquakes on such buildings and their danger to children. Beautiful as they were, all were razed and replaced by low-lying and far less imposing buildings that some detractors referred to as "chicken coops." Nevertheless, the new ones were safe.

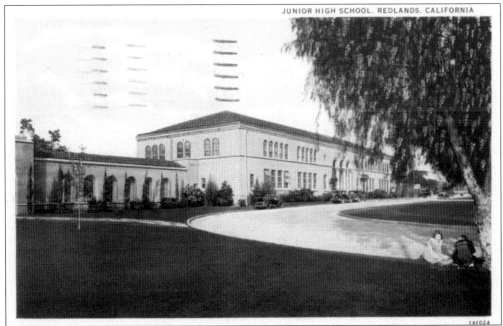

Vintage 1920s and early 1930s cars date this photo postcard of Redlands Junior High School. This classic tile-roofed building across the street from Redlands High School became part of the high school when Cope Junior High was built in 1958. In the late 1960s, it was replaced by new campus buildings.

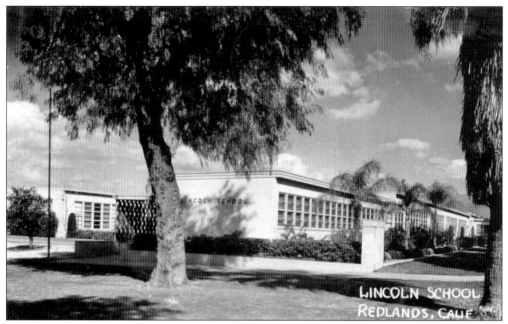

Lincoln School, shown on this 1943 postcard, was built shortly before the outbreak of World War II. A beautiful, modern school, all on one level, it conformed to the earthquake safety standards of the Field Act.

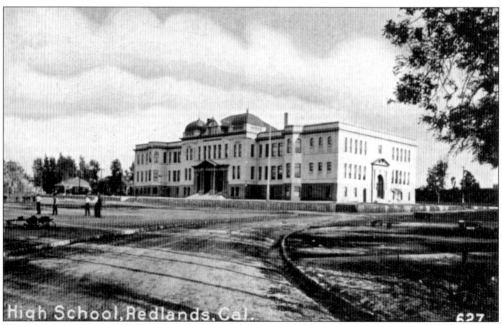

Many Redlands residents remember going to school or teaching in this 1904 Redlands High School building, which replaced an 1893 structure. In the 1950s, a building fund was raised to replace the stately structure.

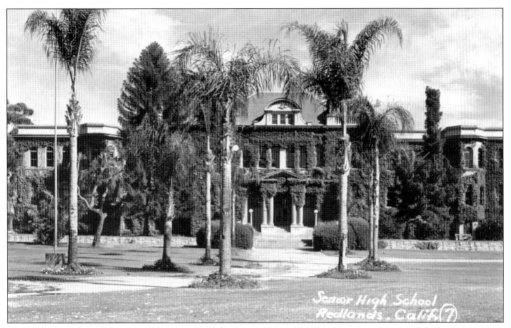

This 1940s-era card shows the same building now heavily vine covered. Printed information on this card indicates that the Redlands High School campus included more than 13 acres. Surely that did not include the vast parking lots that have had to be added in more recent years for students driving their cars to school.

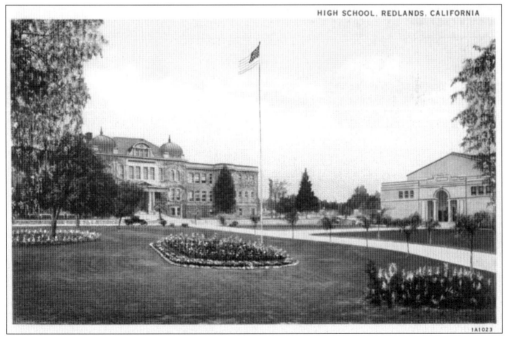

The main entrance to Redlands High School, on Citrus Avenue, shows carefully tended grounds, with the vine-covered main building and Clock Auditorium at right. As Redlands only high school for almost a century, population growth has made it necessary to build more high schools.

Identified simply as "a building at the high school," this structure is Clock Auditorium, where many musical and dramatic presentations continue to be presented every year.

Redlands Preparatory School occupied a large house set in an orange grove. Private schools have come and gone over the years, but a few have remained and been very successful. The one shown here is not among them.

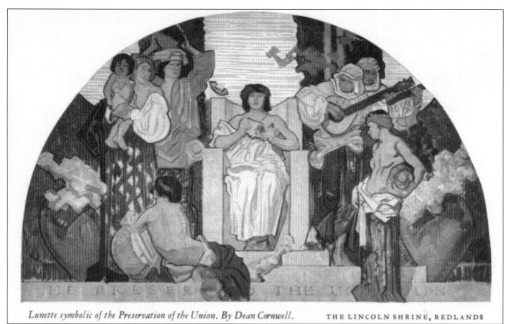

Lunette symbolic of the Preservation of the Union. By Dean Cornwell. THE LINCOLN SHRINE, REDLANDS

Pictured here is one of several fine murals from the interior of the Lincoln Shrine. This archway lunette by artist Dean Cornwell is symbolic of the *Preservation of the Union*. The central rotunda of the Lincoln Shrine is in itself an artistic masterpiece and worthy of a visit.

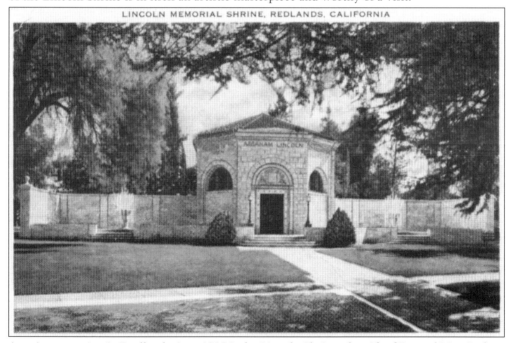

A major attraction in Redlands since 1932 is the Lincoln Shrine, the gift of Dr. and Mrs. Robert Watchorn in memory of their son. The Lincoln Shrine is the repository of the largest collection of Lincoln memorabilia and information west of the Mississippi. The interior features colorful murals by artist Dean Cornwell. The shrine is situated in Smiley Park behind the A. K. Smiley Public Library.

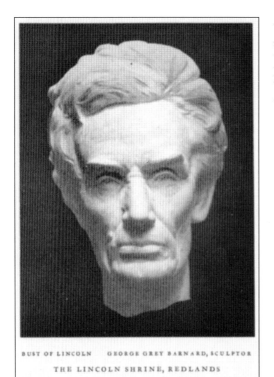

This bust of Lincoln, in white marble by sculptor George Grey Barnard, is one of the Lincoln Shrine's most cherished pieces. Referred to as a "bust," it is really a head. Visitors to the shrine see it directly before them as they enter the front door.

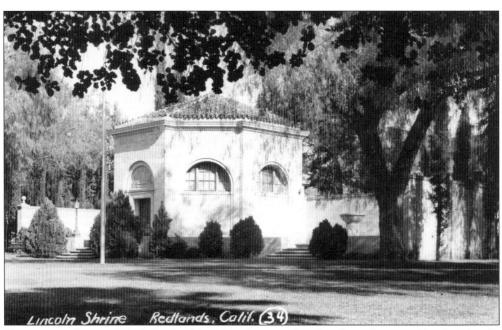

Shown as a rather small building in this 1950s photograph, taken from the west side, the Lincoln Shrine has now been greatly enlarged to accommodate new acquisitions and allow for more of the shrine's holdings to be displayed.

Eight
STATELY HOMES AND NEIGHBORHOODS

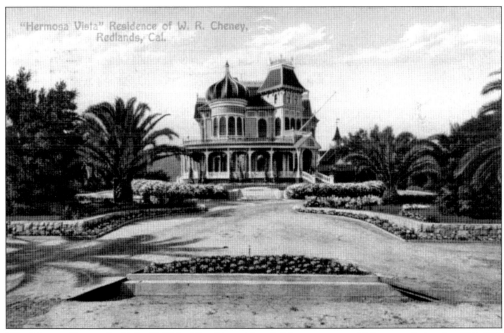

The Morey House, built in 1890 by David and Sarah Morey, was paid for mostly by the $20,000 Sarah had made from selling thousands of seedling navel orange trees. After Mrs. Morey's death, by her own hand, the house became the home of the Cheney family. Mrs. Cheney's niece, Carol Lombard, often visited here as a young girl before becoming famous as an actress. It is often photographed as "America's Victorian."

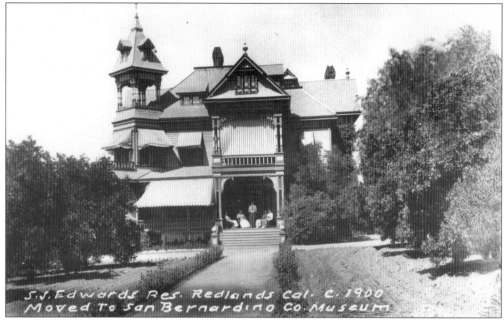

James Samuel Edwards and his wife, Alice, completed their new home in 1891. A long straight driveway through the surrounding orange grove provided a dramatic approach to the house. In the early 1970s, the grove was subdivided for new houses. The house was cut in half and moved through downtown Redlands and several miles away to its new location behind the San Bernardino County Museum.

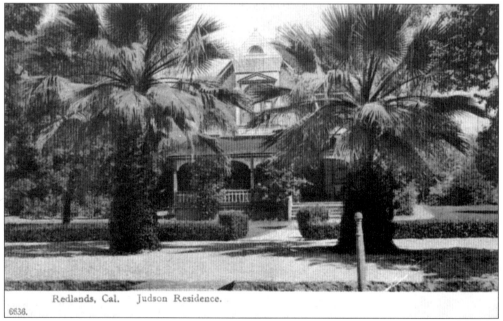

This 1909 postcard shows the unpretentious, though commodious and very beautiful home of Edward Judson, one of the two "Connecticut Yankees," Judson and Brown, who had moved west and started the town of Redlands. They advertised the town in eastern newspapers to entice people to come and live here.

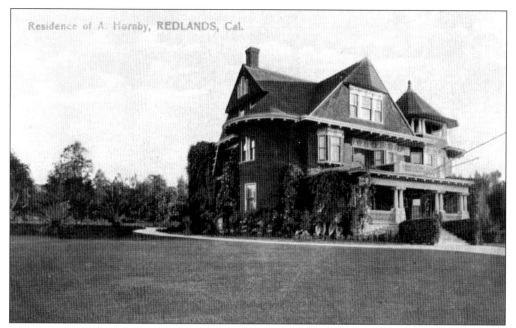

Alonzo and Irene Hornby became wealthy from the manufacture and sale of candy. They built this house in 1896. Generous with their fortune, they supported several local institutions, including the University of Redlands. The Hornby Hall of Science bears their name. Unfortunately, this fine house is another Redlands treasure that was destroyed by fire, on April 21, 1953.

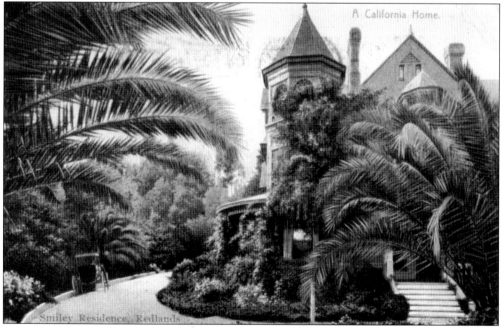

A. K. Smiley's unpretentious, yet idyllic home in Cañon Crest Park welcomed many visitors, including steel multimillionaire philanthropist and library builder Andrew Carnegie and U.S. presidents Theodore Roosevelt and McKinley. Another casualty of fire, this beautiful home burned on April 10, 1953, only 11 days before the Hornby house met the same fate.

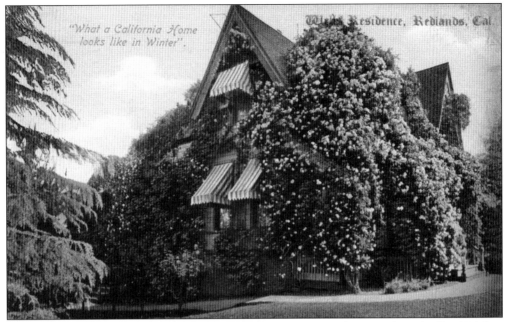

"What a California home looks like in winter" is the caption to this view from Smiley Heights, calculated to seduce the recipient into coming to Redlands. The sender of this 1909 card also wrote, "This place is a Paradise."

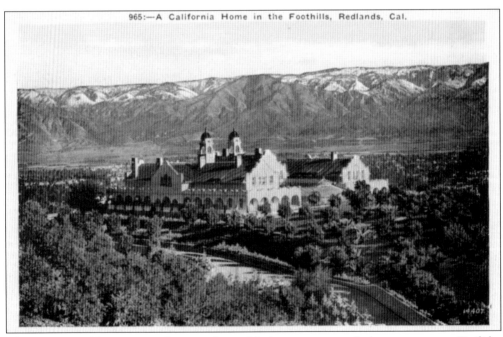

The Burrage residence was truly a mansion, with the appearance of a huge monastery. Built by Albert C. Burrage in 1901, the H-shaped house has 28 rooms and a veranda all the way around. In the center was a large colonnaded hall, a fountain, and an indoor heated swimming pool. The house took 127 workmen four months to build.

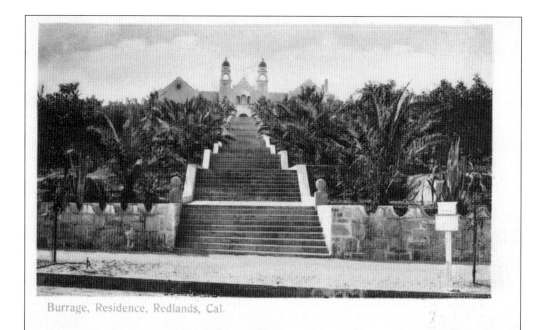

Burrage, Residence, Redlands, Cal.

Pity the poor postman delivering a package up more than 90 steps to the Burrage mansion. There was a driveway, however, directly to the house. One wonders who used this long stairway. Here we see only a small portion of the extensive crenulated stone wall along the street side of the property.

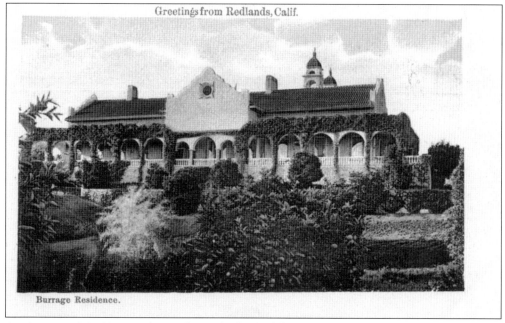

Greetings from Redlands, Calif.

Burrage Residence.

A side view of the Burrage house shows the beautiful vine-covered arches of the house and the profuse growth of trimmed hedges and flowering bushes, reminiscent of some of the famous gardens associated with stately houses in certain parts of Britain or continental Europe.

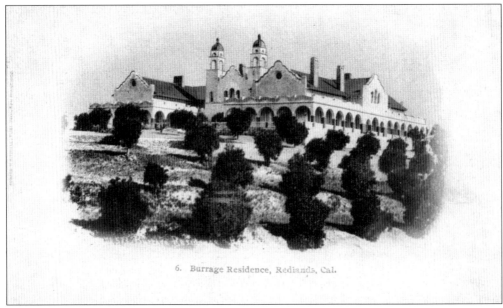

6. Burrage Residence, Redlands, Cal.

The Burrage residence was certainly one of the most prestigious of many fine homes in Redlands, with its tall towers and surrounded by colonnaded verandas on all sides. Here it is also shown atop its hill and surrounded by an orchard of young orange trees.

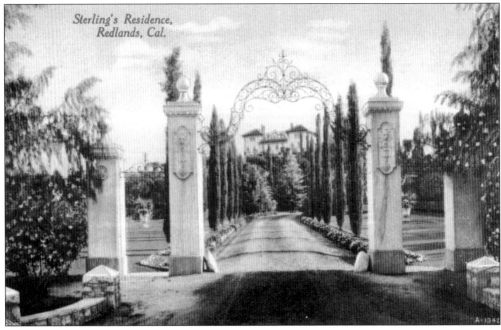

The Sterling residence was approached through these gates and long drive, flanked by tall cypress trees. Two of the gateposts remain today along Crescent Avenue, though some suggest the drive extended farther down toward Highland Avenue.

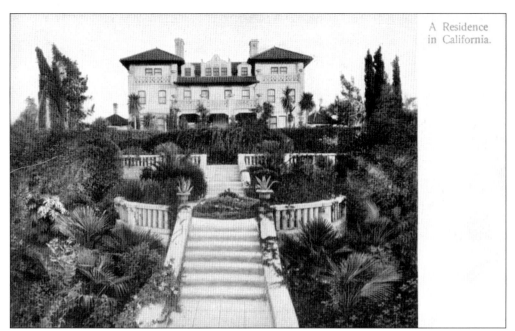

"A Residence in California" seems to suggest that the 22-room Sterling mansion was typical of California homes. Edward Canfield Sterling, a former St. Louis businessman, headed the drive to buy the right-of-way for Sunset Drive. He also invented pressed brick in Redlands, used in many local structures.

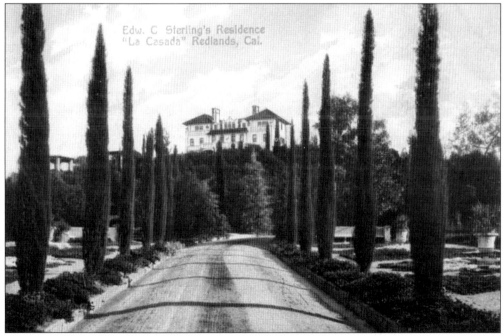

"La Casada" seems a strange name for a Sterling's home. "Casa" is the Spanish word for house, but "la casada" means "the married woman." Perhaps it was the error of a person who knew no Spanish but liked the sound of the word, or perhaps he had other reasons. Note the extensive Italian-style gardens along the drive.

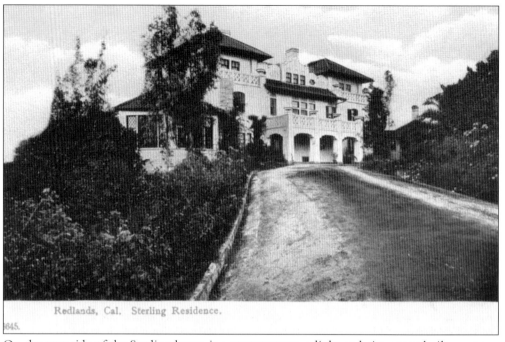

Redlands, Cal. Sterling Residence.

On the near side of the Sterling house is a conservatory, a light and airy room built on many of the large homes, which could have any of several purposes—a sunroom, a place for music or reading, or a place for entertaining guests in a more intimate setting than a larger room.

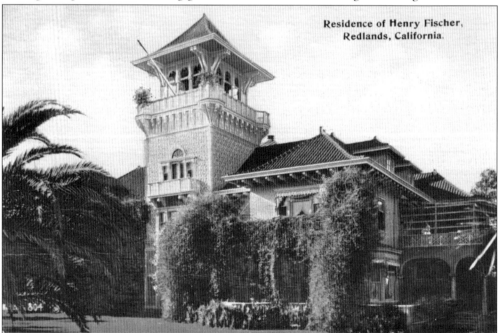

Residence of Henry Fischer, Redlands, California.

Henry Fisher was a very wealthy Pennsylvania oil magnate who built this house in 1897–1898 for his second wife, Marion. His first wife died in 1893. Marion was the younger sister of Fisher's son's wife, who loved elaborate parties and social occasions and was also a talented actress and musician. She frequently starred in dramatic and musical presentations.

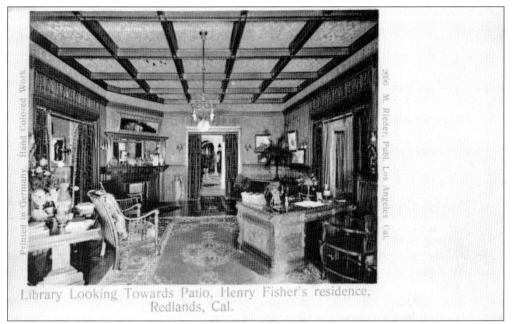

Library Looking Towards Patio, Henry Fisher's residence, Redlands, Cal.

The Fisher home was elaborately appointed and furnished, as shown in this picture of the library. Henry used his considerable wealth to benefit the community, financing electric power generation and rail transportation for Redlands. Marion was the social leader among the mansion crowd. She also organized events to benefit the less fortunate folk and to raise the community's social conscience.

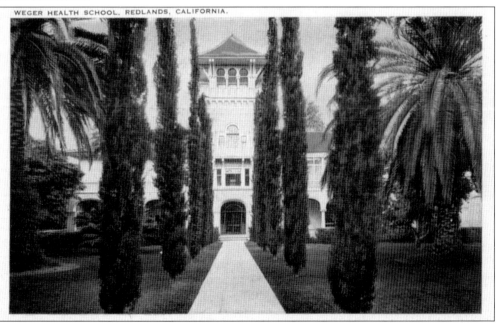

WEGER HEALTH SCHOOL, REDLANDS, CALIFORNIA.

Moorish influence was a popular feature of many stately homes of the era and is apparent here in Fisher's 1898 mansion. A long cypress-lined walk surrounded by lawns and palms made an impressive setting and a dramatic entry to the house. This postcard advertises Weger's Health School.

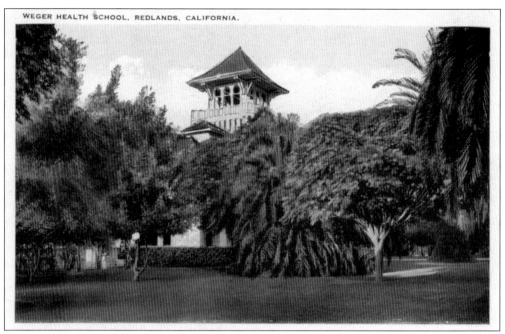

In the late 1920s, the Fisher home became the Weger Health School, headed by Dr. George S. Weger, M.D. All the postcards of the Weger Health School era carried the printed message, "Educational treatment conforming to the most advanced and universally accepted of modern conceptions of impaired health, and its invariable foundation—Toxemia and Enervation."

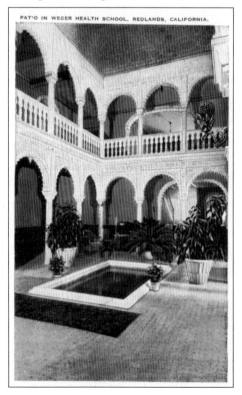

This tile-floored atrium with glass ceiling, graceful decorated columns, and Alhambra-style arches was a central feature of the house and the scene of many a social gathering and costume party for Henry and Marion Fisher. Its use as part of Weger's Health School in the late 1920s is unknown, but it was surely less extravagant and social than in previous years.

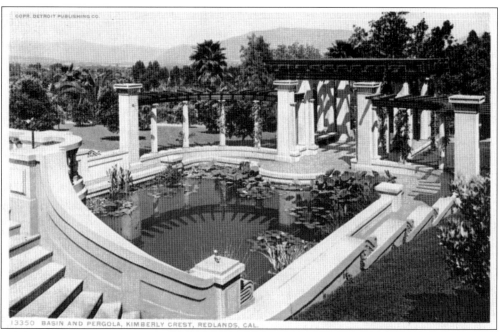

While no cards could be found of the Kimberly Crest mansion, there were two showing the curved steps, pond, and the arbor, or pergola. This card shows the bare structure before flower planters, lamps, or vines were added. In the distance is the San Bernardino mountain range.

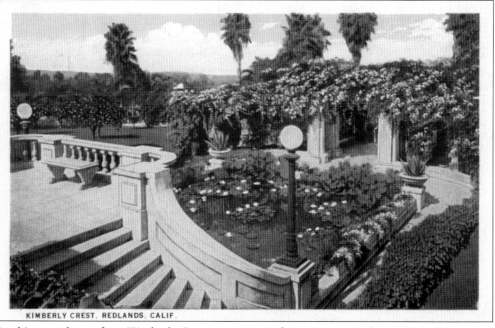

Looking northwest from Kimberly Crest, one surveys the expansive gardens. The double curved staircase leads down around the lily pond to a flower and vine-covered arbor. Many flower boxes and bowls hold exotic and profusely blooming plants.

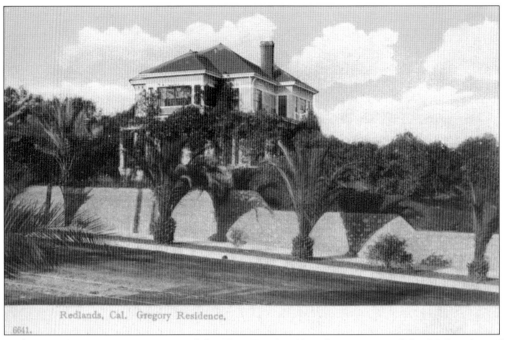

Arthur C. Gregory was a trustee of the First Baptist Church, a trustee of the University of Redlands from 1907 to 1948, and thereafter a trustee emeritus from 1948 to 1954. The Gregory's home, set amidst the orange trees, afforded a pleasant view of the valley.

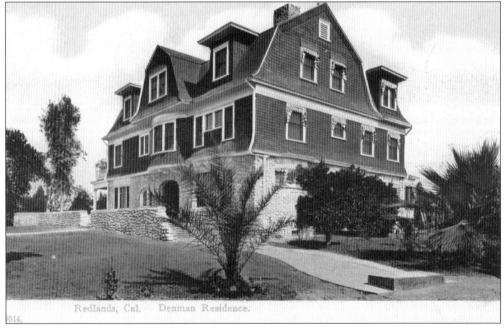

This is the pleasant but unpretentious home of A. C. Denman, who was the vice president of the San Bernardino County Traction Company, the business of which was rail transportation. Henry Fisher was president. Denman was also president of the Redlands Board of Trade when it changed its name and became the Redlands Chamber of Commerce.

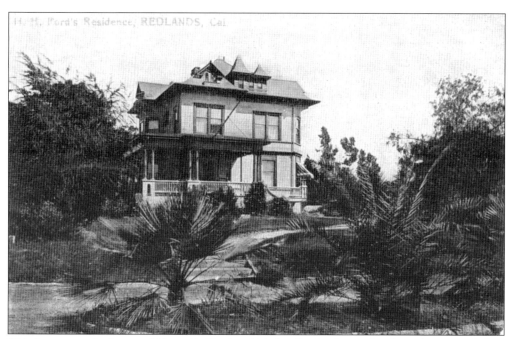

This house was the home of Harry H. Ford and his family. Ford was a banker who succeeded K. C. Wells as president of Union Bank in 1905. Ford was also a Redlands orange grower—whose orchard was virtually destroyed by the great freeze of 1913.

This scene of live oak trees on the corner of Citrus and Brookside Avenues is much different now from the bucolic scene of 1907 pictured here. Today it is the location of the Redlands Post Office, the mall, and the police station.

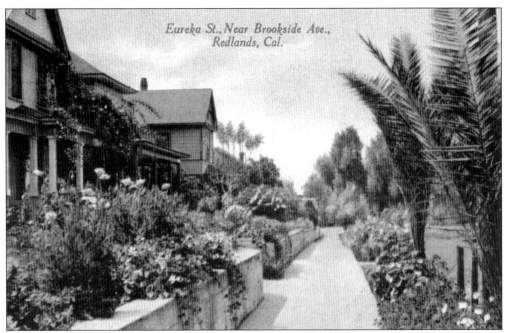

Neighborhoods are made up of people whose homes are near one another, who share a street, see each other's houses, whose children play together, and who may even share a conversation over the back fence. Here is a neighborhood on Eureka Street near Brookside Avenue in Redlands.

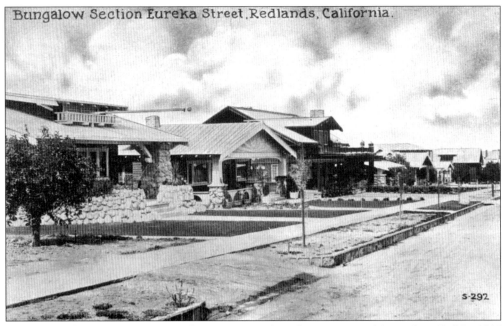

"The Bungalow Section" on Eureka Street sounds rather unique. This card mailed in 1914 shows a row of the then popular Craftsman-style bungalows, all of which look rather new. New trees, cut stone curbs, and concrete sidewalks are in place. Many houses of that era used readily available river rock on porches, pillars, and garden walls.

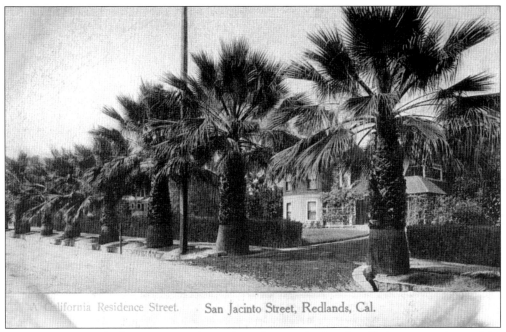

San Jacinto Street, Redlands, Cal.

San Jacinto Street had cut stone curbs, and a palm tree is already splitting out a piece of the curb in the lower right corner. The street was not paved yet, but this was still the horse-and-buggy era, and dirt streets made that more manageable. But by this time there were some motor cars around.

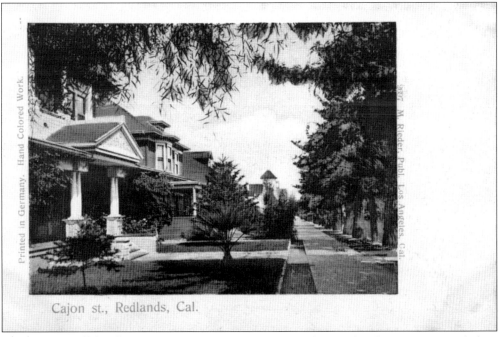

Cajon st., Redlands, Cal.

The homes on Cajon Street were not mansions but were substantial and spacious, nevertheless. Many of these large and gracious homes are still occupied and much in demand by people four or five generations after those who built them.

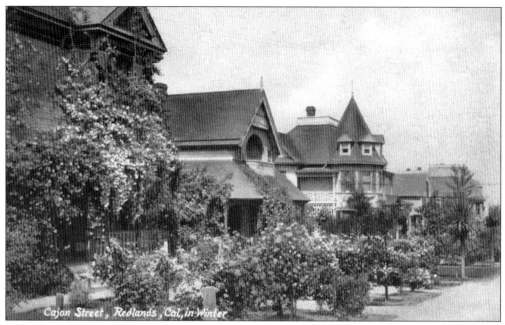

This view of homes along Cajon Street looks like a floral wonderland. Vines climbing up on the houses were not only beautiful but were functional in keeping homes cool in the summer in an era when home insulation was not yet built in.

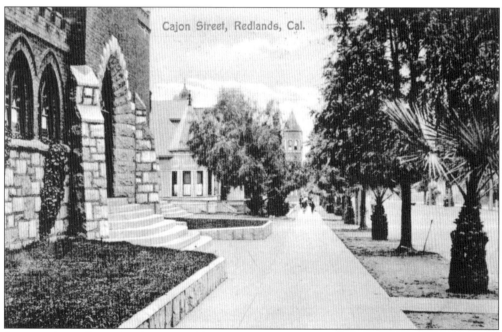

Stone curbs, walls, and archways, and broad sidewalks made the town a good place to walk and gave the appearance of a clean city. This view was on Cajon Street, beside the Congregational church, looking north to the Presbyterian church and the YMCA.

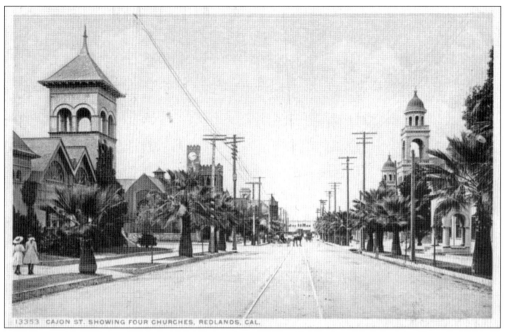

This view looking north on Orange Street shows four churches—three on the left, and one on the right. Still earlier, the white building at far right was the location of Trinity Episcopal Church, before moving to its present location. Note the rails down the center of the street for the Redlands rail transport system.

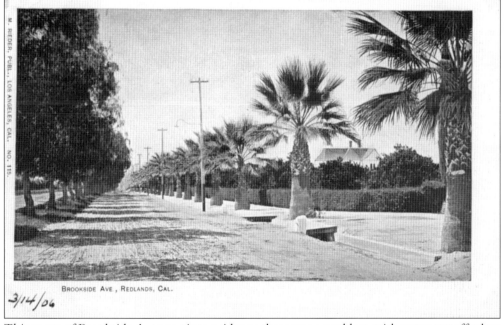

This scene of Brookside Avenue gives evidence there was a problem with water runoff when it rained. The drain channel is deep, and concrete bridges allowed access to driveways. The drains are still there but now underground. The beautiful live oaks still grace this pleasant divided street.

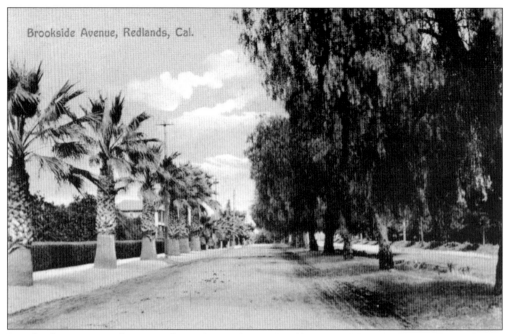

Brookside Avenue a few years later shows the road still unpaved but the deep drain channel now underground. As the area became less agricultural, a nice neighborhood of small homes developed along Brookside Avenue and connecting streets. Many are still residences, but some house businesses compatible with the neighborhood.

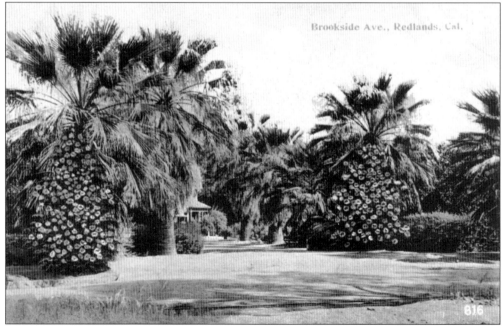

Spectacular flowering vines cover two palm trees in front of a home tucked away in the trees along Brookside Avenue. The photographer may have taken some liberty in exaggerating the size of the blossoms, coloring them red and white on the card. Nevertheless they caught his eye, and he made a fine postcard.

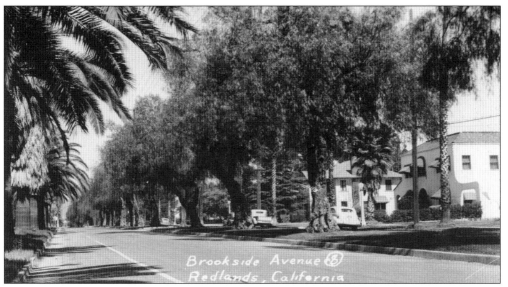

Brookside Avenue, pictured again in the 1940s, shows nicely paved lanes, attractive homes, and the palms and live oak trees that still make this such a lovely and picturesque street in Redlands.

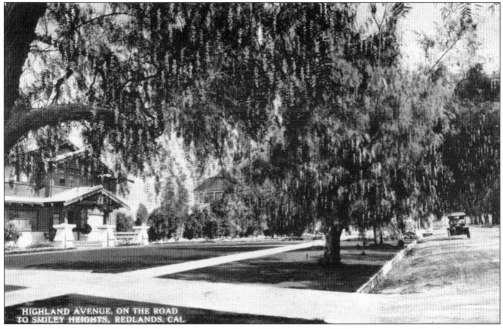

Highland Avenue in Redlands, shown here in a 1920s postcard, boasts some fine large homes, beautiful front yards and gardens, and broad areas that attract many people who want to go for a walk. The neighborhood atmosphere is still there, and homeowners are often open to conversation or a friendly hello.

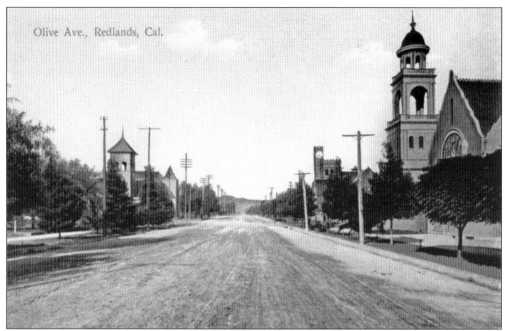

This view of Olive Avenue looking west shows the familiar churches at the corner of Olive and Cajon Streets. Just beyond the churches is a neighborhood of fine old large homes, dating from just before and after the turn of the 19th century. Most are still single-family dwellings, though a few of the largest ones have been converted into apartments.

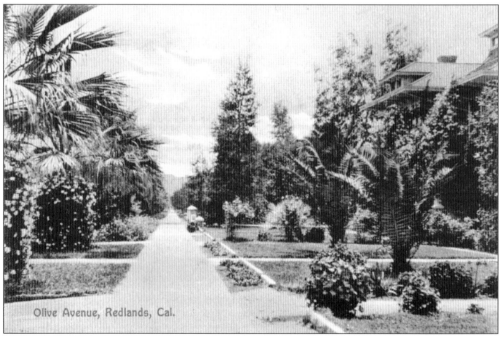

This picture shows the broad sidewalk that leads down along these large homes on West Olive Street. Even today, the sidewalk invites walkers to stroll along and enjoy looking at these grand old homes that offered such gracious surroundings and comfort to their residents and still do.

Nine

Panoramas and Vistas

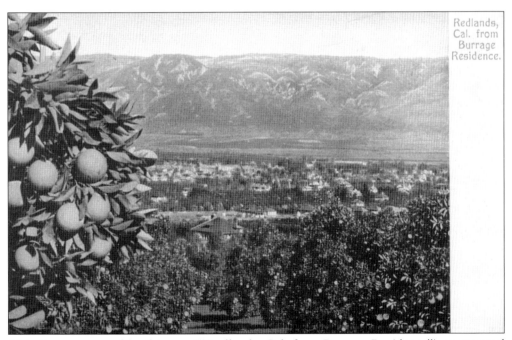

Majestic panoramas like this one ("Redlands, Cal. from Burrage Residence") encouraged snowbound friends and relatives in the East to move to Redlands.

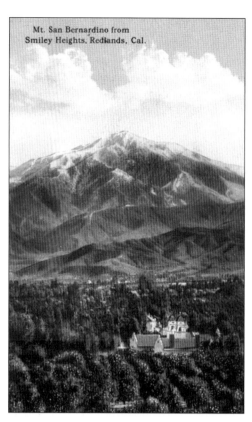

Although Mount San Bernardino seems to dominate the skyline, by no means is it the highest peak in the mountain range. Mount San Gorgonio, or "Greyback," as it is commonly called, is actually the highest peak, located farther east.

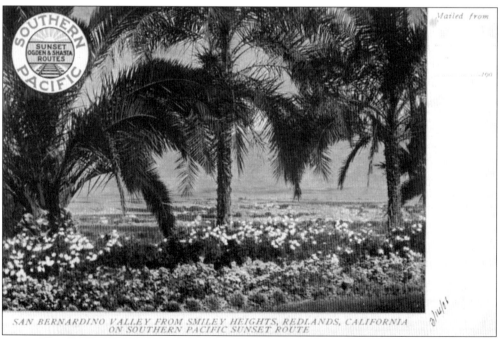

The Southern Pacific Railroad advertised their "Sunset Route" by picturing the magnificent floral vistas from Smiley Heights.

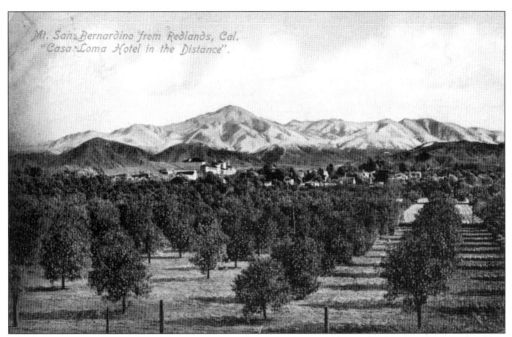

This photograph shows the early town of Redlands looking east from the San Bernardino Valley floor. The large building just left of center is the Casa Loma Hotel.

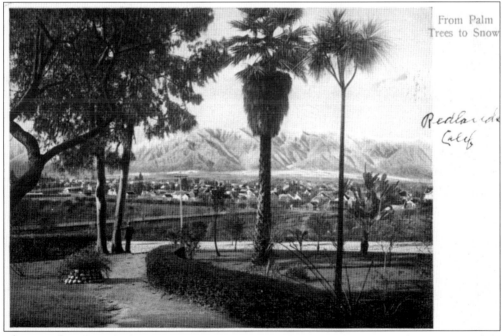

There are few places in America where one can enjoy the view of snowcapped mountains while surrounded by palm trees and orange groves, as advertised here. Locals always loved the snow . . . in the mountains, where it belongs.

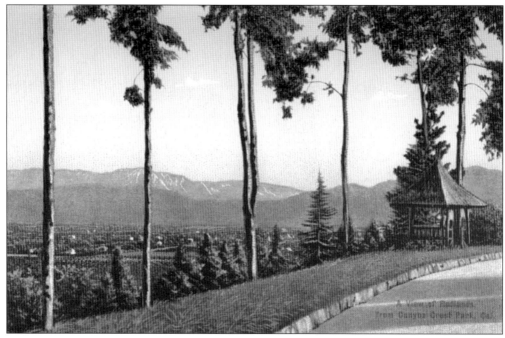

Who would not want to stop and spend some time in a "spooner" gazing at this "View of Redlands from Canyon Crest Park?"

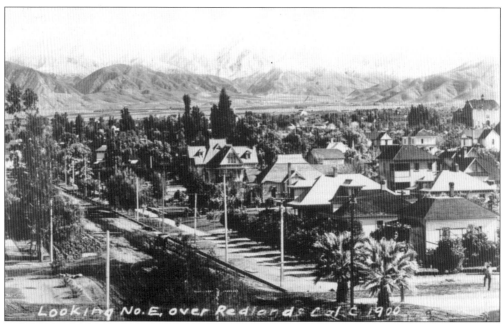

"Looking Northeast over Redlands," the large building at the right is the original Union High School.

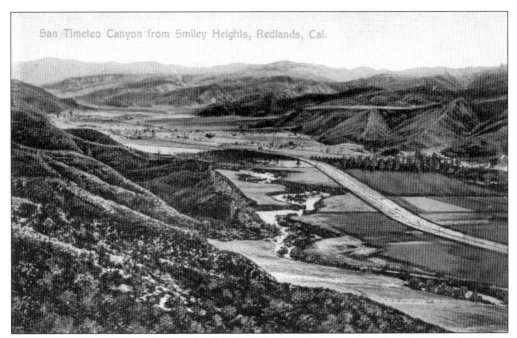

San Timoteo Canyon lies just south of Cañon Crest Park. This view, looking east, shows San Timoteo Creek and the Southern Pacific rail lines.

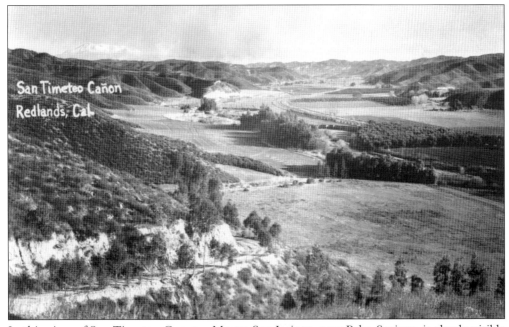

In this view of San Timoteo Canyon, Mount San Jacinto, near Palm Springs, is clearly visible in the distance.

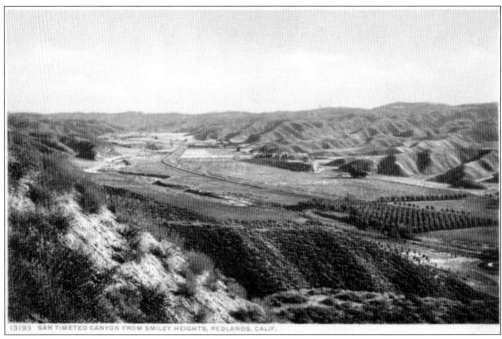

The extensive citrus groves and farming are seen in this view of San Timoteo Canyon.

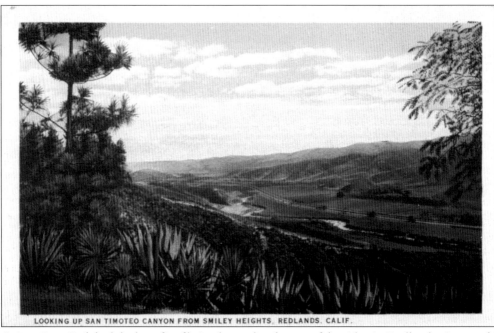

Cañon Crest Park had the benefit of being located at the top of the ridge in Redlands. One could stand and look north to the San Bernardino Valley or look south to the San Timoteo Canyon.

Ten

A Mid-Century View

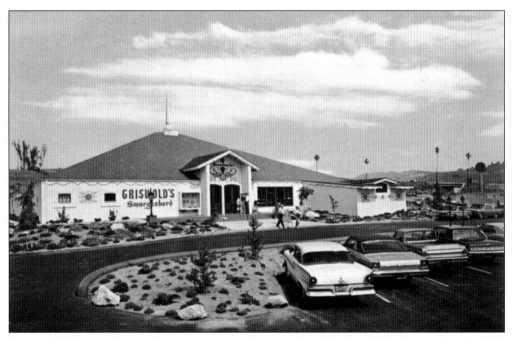

Griswold's Smorgasbord and restaurant moved to Redlands in the 1960s. Located at the I-10 Freeway and Ford Street, it was a favorite eatery for locals and travelers alike.

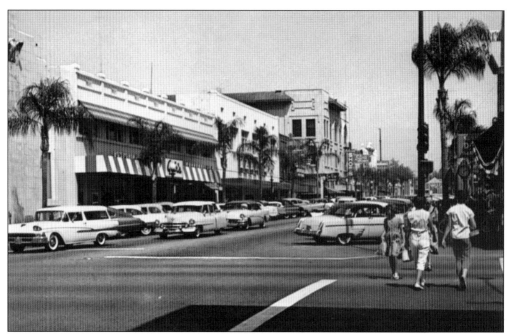

This 1964 view of State Street looking east from Orange Street shows a thoroughly modern downtown. Gair's clothing store is clearly visible on the left after having moved around the corner.

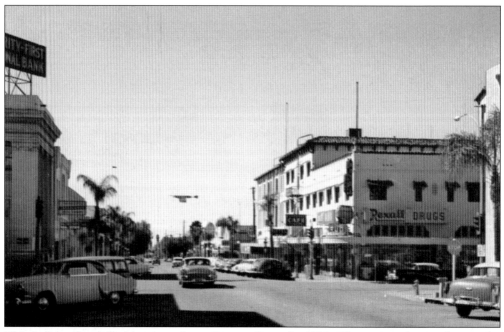

This is State Street looking west from Orange Street in 1955. The La Posada Hotel is on the far right corner, and across the street is the Security Pacific National Bank, formerly the First National Bank of Redlands.

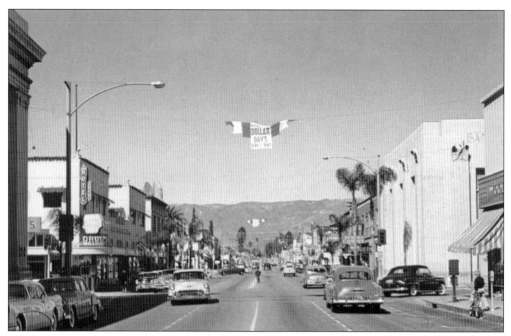

The La Posada Hotel is prominent on the left in this 1950s view of Orange Street, looking north.

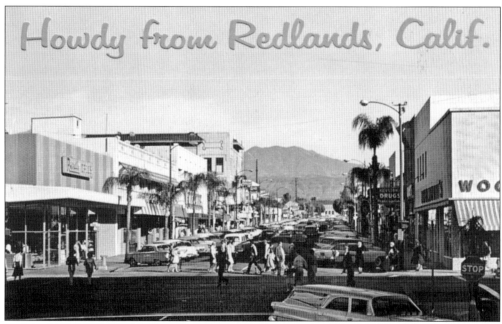

Business seems to be booming on this busy 1950s day on State Street. At the very end of the street, the arches of Redlands Junior High School are visible.

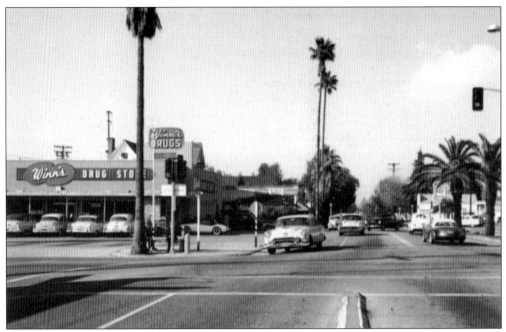

The intersection of Colton Avenue and Orange Street is the location of the ever-popular Winn's Drug Store. Carole's Corner, operated by Carole Ley, was the popular lunch counter inside Winn's Drug Store, with the best apple pie ever tasted.

This shot shows the northeast corner of Colton Avenue and Orange Street, where the grand Casa Loma Hotel once stood.

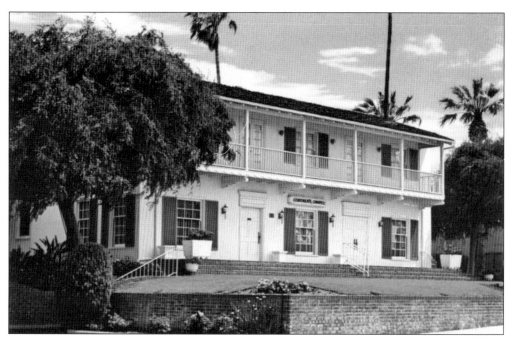

Arthur Cortner arrived in Redlands in 1902 and, by 1924, had founded Cortner Chapel. Originally located at Sixth and Olive Streets, it moved to this new location on Brookside in 1936.

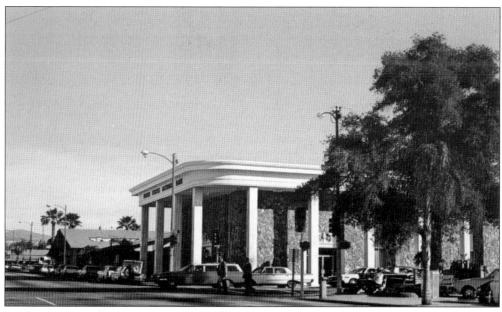

Redlands City Hall now occupies this building, which originally was the United States National Bank. The Fisher Building once stood at the corner.

Milton Sage, a pioneer in the grocery business, opened his Sages super store in Redlands at the corner of Cypress Avenue and Redlands Boulevard. His stores offered innovations such as open refrigerator units with plastic-wrapped meats and cheeses and individual departments including foreign foods, gardening, small appliances, and photography.

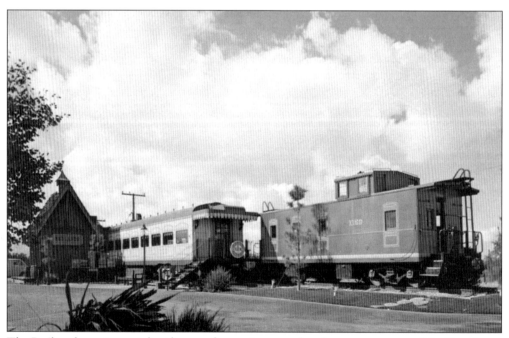

The Railroader restaurant, best known for serving great hamburgers, was one of the first theme restaurants, located just west of Alabama Street at the I-10 Freeway. The dining cars were decorated with railroad memorabilia, and the caboose was the waiting room.

BIBLIOGRAPHY

Brown, John Jr. *History of San Bernardino and Riverside Counties.* Chicago: The Western Historical Association, 1922.

Burgess, Larry E. *The Smileys.* Redlands: Moore Historical Foundation, 1991.

Burgess, Larry E., and Nathan D. Gonzales. Images of America: *Redlands.* Charleston, SC: Arcadia Publishing, 2004.

Christian, Peggy. *Historic San Timoteo Canyon.* Morongo Valley, CA: Sagebrush Press, 2002.

Citrograph Printing Company. *Golden Jubilee Redlands California.* Redlands: Citrograph Printing Company, 1938.

Hinckley, Edith Parker. *On the Banks of the Zanja.* Claremont, CA: The Saunders Press, 1951.

Hein, Erwin S., ed. *The Pictorial History of Redlands and Prospect Park.* Redlands: The Prospect Park Fund.

Ingersoll, L. A. *Ingersoll's Century Annals of San Bernardino County California.* Los Angeles: L. A. Ingersoll, 1904.

Irshay, Phyllis C. *The Pride and Glory of the Town: The Story of the A. K. Smiley Public Library.* City of Redlands, 1988.

Mertins, Esther N. *The First Baptist Church of Redlands, California: 1887–1987.* Redlands, 1987.

Moore, William G. *Redlands Yesterdays.* Redlands: Moore Historical Foundation, 1983.

Nelson, Lawrence Emerson. *Only One Redlands.* Redlands Community Music Association, 1963.

———. *Redlands, Biography of a College.* University of Redlands, 1958.

Nordhoff, Charles. *California for Health, Pleasure, and Residence.* New York: Harper and Brothers, 1873.

Roosevelt, Theodore R. California Addresses.

Signor, John R. *Beaumont Hill.* San Marino, CA: Golden West Books, 1990.

Swett, Ira L. "Tractions of the Orange Empire." *Interurbans* Magazine, 1967.

Across America, People are Discovering Something Wonderful. *Their Heritage.*

Arcadia Publishing is the leading local history publisher in the United States. With more than 3,000 titles in print and hundreds of new titles released every year, Arcadia has extensive specialized experience chronicling the history of communities and celebrating America's hidden stories, bringing to life the people, places, and events from the past. To discover the history of other communities across the nation, please visit:

www.arcadiapublishing.com

Customized search tools allow you to find regional history books about the town where you grew up, the cities where your friends and family live, the town where your parents met, or even that retirement spot you've been dreaming about.